2022 GUIDE
to the
NIGHT SKY

Storm Dunlop and Wil Tirion

Published by Collins
An imprint of HarperCollins*Publishers*
Westerhill Road, Bishopbriggs, Glasgow G64 2QT
www.harpercollins.co.uk

HarperCollins*Publishers*
1st Floor, Watermarque Building, Ringsend Road, Dublin 4, Ireland

In association with
Royal Museums Greenwich, the group name for the National Maritime Museum,
Royal Observatory Greenwich, Queen's House and *Cutty Sark*
www.rmg.co.uk

The contents of this publication are believed correct at the time of printing.
Nevertheless the publisher can accept no responsibility for errors or omissions,
changes in the detail given or for any expense or loss thereby caused.

HarperCollins does not warrant that any website mentioned in this title will be provided uninterrupted,
that any website will be error free, that defects will be corrected, or that the website or the server that
makes it available are free of viruses or bugs. For full terms and conditions please refer to the site
terms provided on the website.

A catalogue record for this book is available from the British Library

ISBN 978-0-00-846986-3

10 9 8 7 6 5 4 3 2 1

Printed in China by RR Donnelley APS

If you would like to comment on any aspect of this book, please contact us at the above address or online.
e-mail: collinsmaps@harpercollins.co.uk

f facebook.com/CollinsAstronomy

@CollinsAstro

MIX
Paper from
responsible sources
FSC
www.fsc.org **FSC™ C007454**

This book is produced from independently certified
FSC™ paper to ensure responsible forest management.

For more information visit: www.harpercollins.co.uk/green

Contents

Introduction

The aim of this Guide is to help people find their way around the night sky, by showing how the stars that are visible change from month to month and by including details of various events that occur throughout the year. The objects and events described may be observed with the naked eye, or nothing more complicated than a pair of binoculars.

The conditions for observing naturally vary over the course of the year. During the summer, twilight may persist throughout the night and make it difficult to see the faintest stars. There are three recognized stages of twilight: civil twilight, when the Sun is less than 6° below the horizon; nautical twilight, when the Sun is between 6° and 12° below the horizon; and astronomical twilight, when the Sun is between 12° and 18° below the horizon. Full darkness occurs only when the Sun is more than 18° below the horizon. During nautical twilight, only the very brightest stars are visible. During astronomical twilight, the faintest stars visible to the naked eye may be seen directly overhead, but are lost at lower altitudes. As the diagram shows, during most of June full darkness never occurs at the

latitude of Vancouver, BC. Slightly farther south (at Seattle, for example) it is truly dark for about two hours, and for somewhere like Houston, TX, there are at least six hours of darkness.

Another factor that affects the visibility of objects is the amount of moonlight in the sky. At Full Moon, it may be very difficult to see some of the fainter stars and objects, and even when the Moon is at a smaller phase it may seriously interfere with visibility if it is near the stars or planets in which you are interested. A full lunar calendar is given for each month and may be used to see when nights are likely to be darkest and best for observation.

The celestial sphere

All the objects in the sky (including the Sun, Moon and stars) appear to lie at some indeterminate distance on a large sphere, centered on the Earth. This *celestial sphere* has various reference points and features that are related to those of the Earth. If the Earth's rotational axis is extended, for example, it points to the North and South Celestial Poles, which are thus in line with the North and South Poles on Earth. Similarly, the *celestial*

The duration of twilight throughout the year at Vancouver and Houston.

VANCOUVER	HOUSTON
Latitude 49.2°N • Longitude -123.1°	Latitude 29.8°N • Longitude -95.4°

Civil Twilight Nautical Twilight Astronomical Twilight Full Darkness

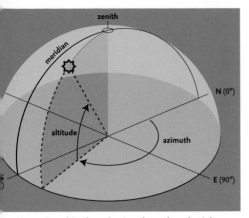

Measuring altitude and azimuth on the celestial sphere.

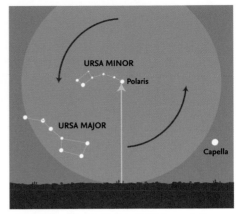

The altitude of the North Celestial Pole equals the observer's latitude.

equator lies in the same plane as the Earth's equator, and divides the sky into northern and southern hemispheres. Because this Guide is written for use in North America, the area of the sky that it describes includes the whole of the northern celestial hemisphere and those portions of the southern that become visible at different times of the year. Stars in the far south, however, remain invisible throughout the year, and are not included.

It is useful to know some of the special terms for various parts of the sky. As seen by an observer, half of the celestial sphere is invisible, below the horizon. The point directly overhead is known as the **zenith**, and the (invisible) one below one's feet as the **nadir**. The line running from the north point on the horizon, up through the zenith and then down to the south point is the **meridian**. This is an important invisible line in the sky because objects are highest in the sky, and thus easiest to see, when they cross the meridian in the south. Objects are said to **transit** when they cross this line in the sky.

In this book, reference is frequently made in the text and in the diagrams to the standard compass points around the horizon. The position of any object in the sky may be described by its **altitude** (measured in degrees above the horizon), and its **azimuth** (measured in degrees from north 0°, through east 90°, south 180° and west 270°). Experienced amateurs and professional astronomers also use another system of specifying locations on the celestial sphere, but that need not concern us here, where the simpler method will suffice.

The celestial sphere appears to rotate about an invisible axis, running between the North and South Celestial Poles. The location (i.e., the altitude) of the Celestial Poles depends entirely on the observer's position on Earth or, more specifically, their latitude. The charts in this book are produced for the latitude of 40°N, so the North Celestial Pole (NCP) is 40° above the northern horizon. The fact that the NCP is fixed relative to the horizon means that all the stars within 40° of the pole are always above the horizon and may, therefore, always be seen at night, regardless of the time of year. This northern circumpolar region is an ideal place to begin learning the sky, and ways to identify the circumpolar stars and constellations will be described shortly.

The ecliptic and the zodiac

Another important line on the celestial sphere is the Sun's apparent path against the background stars – in reality the result of the Earth's orbit around the Sun. This is known as the **ecliptic**. The point where the Sun,

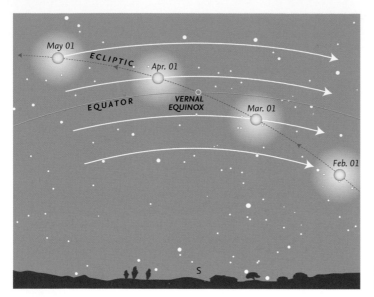

The Sun crossing the celestial equator in spring.

apparently moving along the ecliptic, crosses the celestial equator from south to north is known as the vernal (or spring) equinox, which occurs on March 20. At this time (and at the autumnal equinox, on September 22 or 23, when the Sun crosses the celestial equator from north to south) day and night are almost exactly equal in length. (There is a slight difference, but that need not concern us here.) The vernal equinox is currently located in the constellation of Pisces, and is important in astronomy because it defines the zero point for a system of celestial coordinates, which is, however, not used in this Guide.

The Moon and planets are to be found in a band of sky that extends 8° on either side of the ecliptic. This is because the orbits of the Moon and planets are inclined at various angles to the ecliptic (i.e., to the plane of the Earth's orbit). This band of sky is known as the zodiac and, when originally devised, consisted of 12 **constellations**, all of which were considered to be exactly 30° wide. When the constellation boundaries were formally established by the International Astronomical Union in 1930, the exact extent of most constellations was altered and, nowadays,

the ecliptic passes through 13 constellations. Because of the boundary changes, the Moon and planets may actually pass through several other constellations that are adjacent to the original 12.

The constellations

Since ancient times, the celestial sphere has been divided into various constellations, most dating back to antiquity and usually associated with certain myths or legendary people and animals. Nowadays, the boundaries of the constellations have been fixed by international agreement and their names (in Latin) are largely derived from Greek or Roman originals. Some of the names of the most prominent stars are of Greek or Roman origin, but many are derived from Arabic names. Many bright stars have no individual names and, for many years, stars were identified by terms such as "the star in Hercules' right foot." A more sensible scheme was introduced by the German astronomer Johannes Bayer in the early 17th century. Following his scheme – which is still used today – most of the brightest stars are identified by a Greek letter followed by the genitive form of the constellation's Latin

name. An example is the Pole Star, also known as Polaris and α Ursae Minoris (abbreviated α UMi). The Greek alphabet is shown on page 111 with a list of all the constellations that may be seen from latitude 40°N, together with abbreviations, their genitive forms and English names on page 110. Other naming schemes exist for fainter stars, but are not used in this book.

Asterisms

Apart from the constellations (88 of which cover the whole sky), certain groups of stars, which may form a part of a larger constellation or cross several constellations, are readily recognizable and have been given individual names. These groups are known as *asterisms*, and the most famous (and well-known) is the "Big Dipper," the common name for the seven brightest stars in the constellation of Ursa Major, the Great Bear. The names and details of some asterisms mentioned in this book are given in the list on page 111.

Magnitudes

The brightness of a star, planet or other body is frequently given in magnitudes (mag.). This is a mathematically defined scale where larger numbers indicate a fainter object. The scale extends beyond the zero point to negative numbers for very bright objects. (Sirius, the brightest star in the sky is mag. -1.4.) Most observers are able to see stars to about mag. 6, under very clear skies.

The Moon

Although the daily rotation of the Earth carries the sky from east to west, the Moon gradually moves eastwards by approximately its diameter (about half a degree) in an hour. Normally, in its orbit around the Earth, the Moon passes above or below the direct line between Earth and Sun (at New Moon) or outside the area obscured by the Earth's shadow (at Full Moon). Occasionally, however, the three bodies are more or less perfectly aligned to give an *eclipse*: a solar eclipse at New Moon or a lunar eclipse at Full Moon. Depending on the exact circumstances, a solar eclipse may be merely partial (when the Moon does not cover the whole of the Sun's disk), annular (when the Moon is too far from Earth in its orbit to appear large enough to hide the whole of the Sun), or total. Total and annular eclipses are visible from very restricted areas of the Earth, but partial eclipses are normally visible over a wider area.

Somewhat similarly, at a lunar eclipse, the Moon may pass through the outer zone of the Earth's shadow, the *penumbra* (in a penumbral eclipse, which is not generally perceptible to the naked eye), so that just part of the Moon is within the darkest part of the Earth's shadow, the *umbra* (in a partial eclipse); or completely within the umbra (in a total eclipse). Unlike solar eclipses, lunar eclipses are visible from large areas of the Earth.

Occasionally, as it moves across the sky, the Moon passes between the Earth and individual planets or distant stars, giving rise to an *occultation*. As with solar eclipses, such occultations are visible from restricted areas of the world.

The planets

Because the planets are always moving against the background stars, they are treated in some detail in the monthly pages and information is given when they are close to other planets, the Moon or any of five bright stars that lie near the ecliptic. Such events are known as *appulses* or, more frequently, as *conjunctions*. (There are technical differences in the way these terms are defined and should be used in astronomy, but these need not concern us here.) The positions of the planets are shown for every month on a special chart of the ecliptic.

The term conjunction is also used when a planet is either directly behind or in front of the Sun, as seen from Earth. (Under normal circumstances it will then be invisible.) The conditions of most favorable visibility depend on whether the planet is one of the two known as *inferior planets* (Mercury and Venus) or one of the three *superior planets* (Mars, Jupiter and

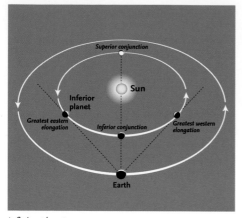

Inferior planet.

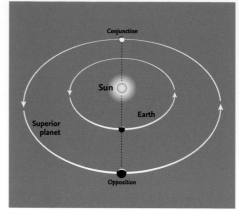

Superior planet.

Saturn) that are covered in detail. (Some details of the fainter superior planets, Uranus and Neptune, are included in this Guide, and special charts for both are given on page 25.)

The inferior planets are most readily seen at eastern or western **elongation**, when their angular distance from the Sun is greatest. For superior planets, they are best seen at **opposition**, when they are directly opposite the Sun in the sky, and cross the meridian at local midnight.

It is often useful to be able to estimate angles on the sky, and approximate values may be obtained by holding one hand at arm's length. The various angles are shown in the diagram, together with the separations of the various stars in the Big Dipper.

Meteors

At some time or other, nearly everyone has seen a **meteor** – a "shooting star" – as it flashed across the sky. The particles that cause meteors – known technically as "meteoroids" – range in size from that of a grain of sand (or even smaller) to the size of a pea. On any night of the year there are occasional meteors, known as **sporadics**, that may travel in any direction. These occur at a rate that is normally between three and eight in an hour. Far more important, however, are **meteor showers**, which occur at fixed periods of the year, when the

Earth encounters a trail of particles left behind by a comet or, very occasionally, by a minor planet (asteroid). Meteors always appear to diverge from a single point on the sky, known as the **radiant**, and the radiants of major showers are shown on the charts. Meteors that come from a circular area 8° in diameter around the radiant are classed as belonging to the particular shower. All others that do not come from that area are sporadics (or, occasionally from another shower that is active at the same time). A list of the major meteor showers is given on page 31.

Although the positions of the various shower radiants are shown on the charts, looking directly at the radiant is not the most effective way of seeing meteors. They are most likely to be noticed if one is looking about 40°–45° away from the radiant position. (This is approximately two hand-spans as shown in the diagram for measuring angles.)

Other objects

Certain other objects may be seen with the naked eye under good conditions. Some were given names in antiquity – Praesepe is one example – but many are known by what are called "Messier numbers," the numbers in a catalogue of nebulous objects compiled by Charles Messier in the late 18th century. Some, such as the Andromeda Galaxy, M31, and the Orion Nebula, M42, may be seen

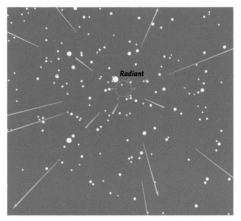

Meteor shower (showing the April Lyrid radiant).

Measuring angles in the sky.

by the naked eye, but all those given in the list will benefit from the use of binoculars. Apart from galaxies, such as M31, which contain thousands of millions of stars, there are also two types of cluster: open clusters, such as M45, the Pleiades, which may consist of a few dozen to some hundreds of stars; and globular clusters, such as M13 in Hercules, which are spherical concentrations of many thousands of stars. One or two gaseous nebulae, consisting of gas illuminated by stars within them, are also visible. The Orion Nebula, M42, is one, and is illuminated by the group of four stars, known as the Trapezium, which may be seen within it by using a good pair of binoculars.

Some interesting objects.

Messier / NGC	Name	Type	Constellation	Maps (months)
—	Hyades	open cluster	Taurus	Sep. – Mar.
—	Double Cluster	open cluster	Perseus	All year
—	Melotte 111 (Coma Cluster)	open cluster	Coma Berenices	Jan. – Aug.
M3	—	globular cluster	Canes Venatici	Feb. – Sep.
M4	—	globular cluster	Scorpius	May – Aug.
M8	Lagoon Nebula	gaseous nebula	Sagittarius	Jun. – Sep.
M11	Wild Duck Cluster	open cluster	Scutum	May – Oct.
M13	Hercules Cluster	globular cluster	Hercules	Mar. – Oct.
M15	—	globular cluster	Pegasus	Jun. – Dec.
M20	Trifid Nebula	gaseous nebula	Sagittarius	Jun. – Sep.
M22	—	globular cluster	Sagittarius	Jun. – Sep.
M27	Dumbbell Nebula	planetary nebula	Vulpecula	May – Nov.
M31	Andromeda Galaxy	galaxy	Andromeda	Jun. – Mar.
M35	—	open cluster	Gemini	Oct. – Apr.
M42	Orion Nebula	gaseous nebula	Orion	Nov. – Mar.
M44	Praesepe	open cluster	Cancer	Nov. – Jun.
M45	Pleiades	open cluster	Taurus	Sep. – Mar.
M57	Ring Nebula	planetary nebula	Lyra	Apr. – Nov.
M67	—	open cluster	Cancer	Dec. – May
NGC 752	—	open cluster	Andromeda	Jul. – Mar.
NGC 3242	Ghost of Jupiter	planetary nebula	Hydra	Feb. – May

The Northern Circumpolar Constellations

The northern circumpolar stars are the key to starting to identify the constellations. For anyone in the northern hemisphere they are visible at any time of the year, and nearly everyone is familiar with the seven stars of the Big Dipper: an asterism that forms part of the large constellation of **Ursa Major** (the Great Bear).

Ursa Major

Because of the movement of the stars caused by the passage of the seasons, Ursa Major lies in different parts of the evening sky at different periods of the year. The diagram below shows its position of the beginning of the four main seasons. The seven stars of the Big Dipper remain visible throughout the year anywhere north of latitude 40°N. Even at the latitude (40°N) for which the charts in this book are drawn, many of the stars in the southern portion of the constellation of Ursa Major are hidden below the horizon for part of the year or (particularly in late summer) cannot be seen late in the night.

Polaris and Ursa Minor

The two stars **Dubhe** and **Merak** (α and β Ursae Majoris, respectively), farthest from the "tail"

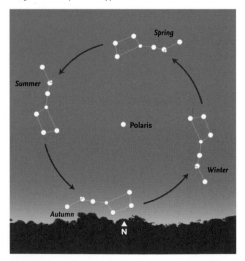

are known as the "Pointers." A line from Merak to Dubhe, extended about five times their separation, leads to the Pole Star, **Polaris**, or α Ursae Minoris. All the stars in the northern sky appear to rotate around it. There are five main stars in the constellation of **Ursa Minor**, and the two farthest from the Pole, **Kochab** and **Pherkad** (β and γ Ursae Minoris, respectively), are known as "The Guards."

Cassiopeia

On the opposite of the North Pole from Ursa Major lies **Cassiopeia**. It is highly distinctive, appearing as five stars forming a letter "W" or "M" depending on its orientation. Provided the sky is reasonably clear of clouds, you will nearly always be able to see either Ursa Major or Cassiopeia, and thus be able to orientate yourself on the sky.

To find Cassiopeia, start with **Alioth** (ε Ursae Majoris), the first star in the tail of the Great Bear. A line from this star extended through Polaris points directly toward γ Cassiopeiae, the central star of the five.

Cepheus

Although the constellation of **Cepheus** is fully circumpolar, it is not nearly as well-known as Ursa Major, Ursa Minor or Cassiopeia, partly because its stars are fainter. Its shape is rather like the end of a house with a pointed roof. The line from the Pointers through Polaris, if extended, leads to **Errai** (γ Cephei) at the "top" of the "roof." The brightest star, **Alderamin** (α Cephei) lies in the Milky Way region, at the "bottom right-hand corner" of the figure.

Draco

The constellation of **Draco** consists of a quadrilateral of stars, known as the "Head of Draco" (and also the "Lozenge"), and a long chain of stars forming the neck and body of the dragon. To find the Head of Draco, locate the two stars **Phecda** and **Megrez** (γ and δ Ursae Majoris) in the Big Dipper,

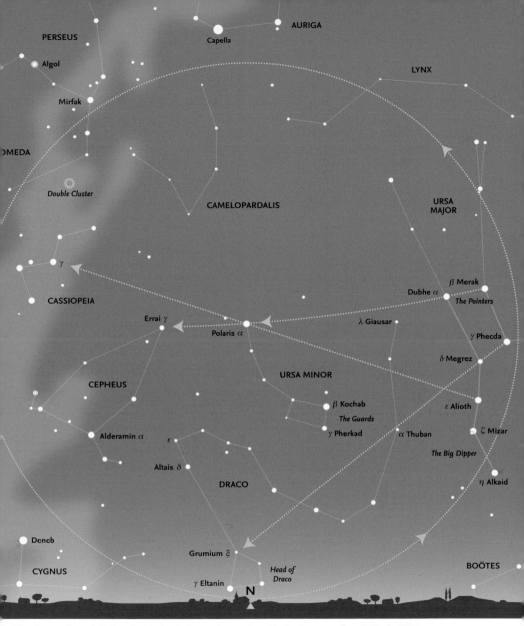

The stars and constellations inside the circle are always above the horizon, seen from latitude 40°N.

opposite the Pointers. Extend a line from Phecda through Megrez by about eight times their separation, right across the sky below the Guards in Ursa Minor, ending at **Grumium** (ξ Draconis) at one corner of the quadrilateral. The brightest star, **Eltanin** (γ Draconis) lies farther to the south. From the head of Draco, the constellation first runs northeast to **Altais** (δ Draconis) and ε Draconis, then doubles back southwards before winding its way through **Thuban** (α Draconis) before ending at **Giausar** (λ Draconis) between the Pointers and Polaris.

The Winter Constellations

The winter sky is dominated by several bright stars and distinctive constellations. The most conspicuous constellation is **Orion**, the main body of which has an hour-glass shape. It straddles the celestial equator and is thus visible from anywhere in the world. The three stars that form the "Belt" of Orion point down toward the southeast and to **Sirius** (α Canis Majoris), the brightest star in the sky. **Mintaka** (δ Orionis), the star at the northeastern end of the Belt, farthest from Sirius, actually lies just slightly south of the celestial equator.

A line from **Bellatrix** (γ Orionis) at the "top right-hand corner" of Orion, through **Aldebaran** (α Tauri), past the "V" of the Hyades cluster, points to the distinctive cluster of bright blue stars known as the **Pleiades**, or the "Seven Sisters." Aldebaran is one of the five bright stars that may sometimes be occulted (hidden) by the Moon. Another line from Bellatrix, through **Betelgeuse** (α Orionis), if carried right across the sky, points to the constellation of **Leo**, a prominent constellation in the spring sky.

Six bright stars in six different constellations: **Capella** (α Aurigae), **Aldebaran** (α Tauri), **Rigel** (β Orionis), **Sirius** (α Canis Majoris), **Procyon** (α Canis Minoris) and **Pollux** (β Gemini) form what is sometimes known as the "Winter Hexagon." Pollux is accompanied to the northwest by the slightly fainter star of **Castor** (α Gemini), the second "Twin."

In a counterpart to the famous "Summer Triangle," an almost perfect equilateral triangle, the "Winter Triangle," is formed by Betelgeuse (α Orionis), Sirius (α Canis Majoris) and Procyon (α Canis Minoris).

Several of the stars in this region of the sky show distinctive tints: Betelgeuse (α Orionis) is reddish, Aldebaran (α Tauri) is orange and Rigel (β Orionis) is blue-white.

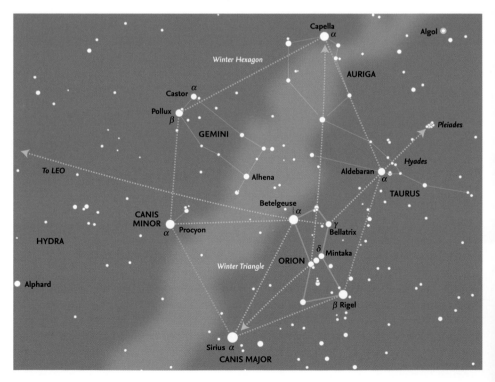

The Spring Constellations

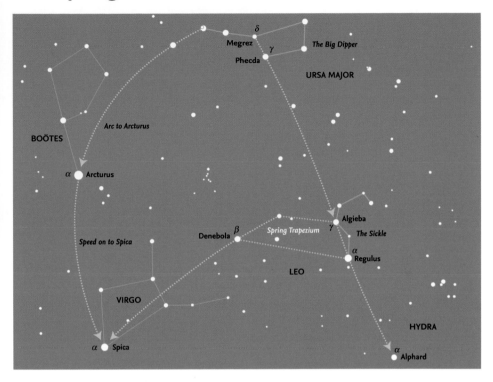

The most prominent constellation in the spring sky is the zodiacal constellation of **Leo**, and its brightest star, **Regulus** (α Leonis), which may be found by extending a line from Megrez and Phecda (δ and γ Ursae Majoris, respectively) – the two stars on the opposite side of the bowl of the Big Dipper from the Pointers – down to the southeast. Regulus forms the "dot" of the "backward question mark" known as "the Sickle." Regulus, like Aldebaran in Taurus is one of the bright stars that lie close to the ecliptic, and that are occasionally occulted by the Moon. The same line from Ursa Major to Regulus, if continued, leads to **Alphard** (α Hydrae), the brightest star in **Hydra**, the largest of the 88 constellations.

The shape formed by the body of Leo is sometimes known as the "Spring Trapezium." At the other end of the constellation from Regulus is **Denebola** (β Leonis), and the line forming the back of the constellation through Denebola points to the bright star **Spica** (α Virginis) in the constellation of **Virgo**. A saying that helps to locate Spica is well-known to astronomers: "Arc to Arcturus and then speed on to Spica." This suggests following the arc of the tail of Ursa Major to Arcturus and then on to Spica. **Arcturus** (α Boötis) is actually the brightest star in the northern hemisphere of the sky. (Although other stars, such as Sirius, are brighter, they are all in the southern hemisphere.) Overall, the constellation of **Boötes** is sometimes described as "kite-shaped" or "shaped like the letter P."

Although Spica is the brightest star in the zodiacal constellation of Virgo, the rest of the constellation is not particularly distinct, consisting of a rough quadrilateral of moderately bright stars and some fainter lines of stars extending outwards.

The Summer Constellations

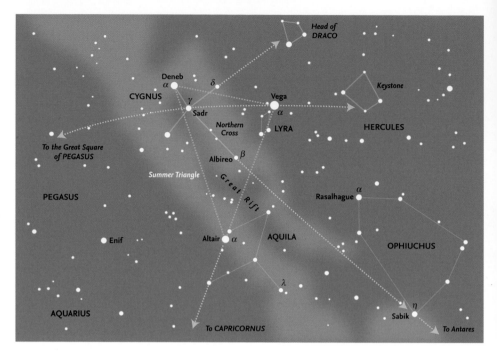

On summer nights, the three bright stars **Deneb** (α Cygni), **Vega** (α Lyrae) and **Altair** (α Aquilae) form the striking "Summer Triangle." The constellations of **Cygnus** (the Swan) and **Aquila** (the Eagle) represent birds "flying" down the length of the Milky Way. This part of the Milky Way contains the **Great Rift**, an elongated dark region, where the light from distant stars is obscured by intervening dust. The dark Rift is clearly visible even to the naked eye.

The most prominent stars of Cygnus are sometimes known as the "Northern Cross" (as a counterpart to the "Southern Cross" – the constellation of Crux – in the southern hemisphere). The central line of Cygnus through **Albireo** (β Cygni), extended well to the southwest, points to **Sabik** (η Ophiuchi) in the large, sprawling constellation of **Ophiuchus** (the Serpent Bearer) and beyond to **Antares** (α Scorpii) in the constellation of **Scorpius**. Like Cepheus, the shape of Ophiuchus somewhat resembles the gable-end of a house, and the

brightest star **Rasalhague** (α Ophiuchi) is at the "apex" of the "gable."

A line from the central star of Cygnus, **Sadr** (γ Cygni) through δ Cygni, in the northwestern "wing" points toward the Head of Draco, and is another way of locating that part of the constellation. Another line from Sadr to Vega indicates the central portion, "The Keystone," of the constellation of **Hercules**. An arc through the same stars, in the opposite direction, points toward the constellation of **Pegasus**, and more specifically to the "Great Square of Pegasus."

Aquila is less conspicuous than Cygnus and consists of a diamond shape of stars, representing the body and wings of the eagle, together with a rather faint star, λ Aquilae, marking the "head." **Lyra** (the Lyre) mainly consists of Vega (α Lyrae) and a small quadrilateral of stars to its southeast. Continuation of a line from Vega through Altair indicates the zodiacal constellation of **Capricornus**.

The Autumn Constellations

During the autumn season, the most striking feature is the "Great Square of Pegasus," an almost perfect rectangle on the sky, forming the main body of the constellation of **Pegasus**. However, the star at the northeastern corner, **Alpheratz**, is actually α Andromedae, and part of the adjacent constellation of **Andromeda**. A line from **Scheat** (β Pegasi) at the northeastern corner of the Square, through **Matar** (η Pegasi), points in the general direction of Cygnus. A crooked line of stars leads from **Markab** (α Pegasi) through **Homam** (ζ Pegasi) and **Biham** (θ Pegasi) to **Enif** (ε Pegasi). A line from Markab through the last star in the Square, **Algenib** (γ Pegasi) points in the general direction of the five stars, including **Menkar** (α Ceti) that form the "tail" of the constellation of **Cetus** (the Whale). A ring of seven stars lying below the southern side of the Great Square is known as "the Circlet," part of the constellation of **Pisces** (the Fishes).

Extending the line of the western side of the Great Square toward the south leads to the isolated bright star, **Fomalhaut** (α Piscis Austrini), in the Southern Fish. Following the line of the eastern side of the Great Square toward the north leads to Cassiopeia while, in the other direction, it points toward **Diphda** (β Ceti), which is actually the brightest star in Cetus.

Three bright stars leading northeast from Alpheratz form the main body of the constellation of **Andromeda**. Continuation of that line leads toward the constellation of **Perseus** and **Mirfak** (α Persei). Running southwards from Mirfak is a chain of stars, one of which is the famous variable star **Algol** (β Persei). Farther east, an arc of stars leads to the prominent cluster of the **Pleiades**, in the constellation of **Taurus**.

Between Andromeda and Cetus lie the two small constellations of **Triangulum** (the Triangle) and **Aries** (the Ram).

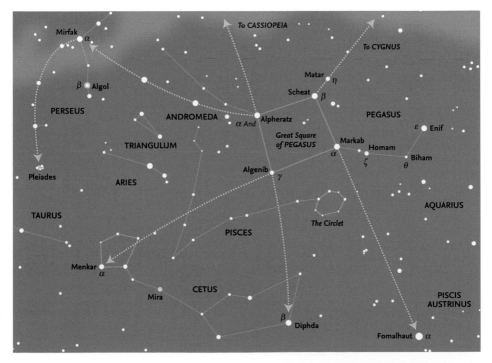

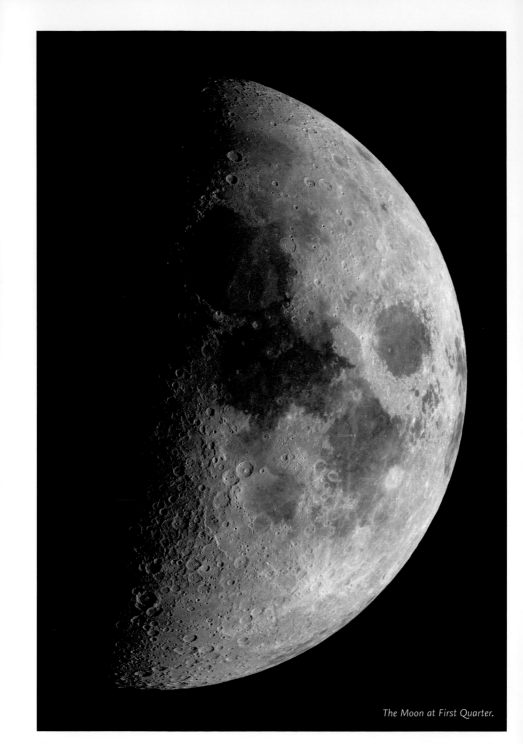

The Moon at First Quarter.

The Moon

The monthly pages include diagrams showing the phase of the Moon for every day of the month, and also indicate the day in the **lunation** (or **age** of the Moon), which begins at New Moon. Although the main features of the surface – the light highlands and the dark maria (seas) – may be seen with the naked eye, far more features may be detected with the use of binoculars or any telescope. The many craters are best seen when they are close to the **terminator** (the boundary between the illuminated and the non-illuminated areas of the surface), when the Sun rises or sets over any particular region of the Moon and the crater walls or central peaks cast strong shadows. Most features become difficult to see at Full Moon, although this is the best time to see the bright ray systems surrounding certain craters. Accompanying the Moon map on the following pages is a list of prominent features, including the days in the lunation when features are normally close to the terminator and thus easiest to see. A few bright features

such as Linné and Proclus, visible when well illuminated, are also listed. One feature, Rupes Recta (the Straight Wall) is readily visible only when it casts a shadow with light from the east, appearing as a light line when illuminated from the opposite direction.

The dates of visibility vary slightly through the effects of **libration**. Because the Moon's orbit is inclined to the Earth's equator and also because it moves in an ellipse, the Moon appears to rock slightly from side to side (and nod up and down). Features near the **limb** (the edge of the Moon) may vary considerably in their location and visibility. (This is easily noticeable with Mare Crisium and the craters Tycho and Plato.) Another effect is that at crescent phases before and after New Moon, the normally non-illuminated portion of the Moon receives a certain amount of light, reflected from the Earth. This **Earthshine** may enable certain bright features (such as Aristarchus, Kepler and Copernicus) to be detected even though they are not illuminated by sunlight.

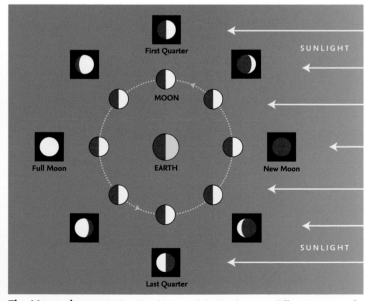

The Moon phases. *During its orbit around the Earth we see different portions of the illuminated side of the Moon's surface.*

Map of the Moon

Abulfeda	6:20
Agrippa	7:21
Albategnius	7:21
Aliacensis	7:21
Alphonsus	8:22
Anaxagoras	9:23
Anaximenes	11:25
Archimedes	8:22
Aristarchus	11:25
Aristillus	7:21
Aristoteles	6:20
Arzachel	8:22
Atlas	4:18
Autolycus	7:21
Barrow	7:21
Billy	12:26
Birt	8:22
Blancanus	9:23
Bullialdus	9:23
Bürg	5:19
Campanus	10:24
Cassini	7:21
Catharina	6:20
Clavius	9:23
Cleomedes	3:17
Copernicus	9:23
Cyrillus	6:20
Delambre	6:20
Deslandres	8:22
Endymion	3:17
Eratosthenes	8:22
Eudoxus	6:20
Fra Mauro	9:23
Fracastorius	5:19
Franklin	4:18
Gassendi	11:25
Geminus	3:17
Goclenius	4:18
Grimaldi	13-14:27-28
Gutenberg	5:19
Hercules	5:19
Herodotus	11:25
Hipparchus	7:21
Hommel	5:19
Humboldt	3:15
Janssen	4:18
Julius Caesar	6:20
Kepler	10:24
Landsberg	10:24
Langrenus	3:17
Letronne	11:25
Linné	6
Longomontanus	9:23

The numbers indicate the age of the Moon when features are usually best visible.

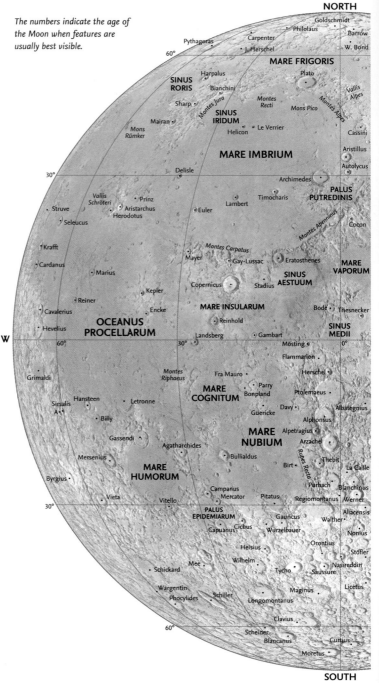

18

NORTH

Goldschmidt · Meton
Barrow
W. Bond · Arnold
60°
MARE
FRIGORIS
Endymion ·
Vallis · Aristoteles
Alpes
Montes Alpes
LACUS · Mercurius
Eudoxus · MORTIS · Bürg · Hercules · Atlas
Cassini
Cepheus ·
LACUS
Montes · SOMNIORUM · Franklin ·
Aristillus · Caucasus
Geminus · Gauss ·
Archimedes · · Autolycus · MARE · Posidonius · Berosus
SERENITATIS · Chacornac · Burckhardt · Hahn
PALUS · Linné · 30°
PUTREDINIS · Le Monnier · Cleomedes ·
Montes Haemus
· Cocon · Bessel · Macrobius
Montes
Apenninus · Manilius · Menelaus · Plinius · Vetruvius
MARE · MARE
VAPORUM · CRISIUM
· Hyginus · PALUS
SOMNI · Picard
Bode · · Triesnecker · MARE · · Condorcet
· Agrippa · TRANQUILLITATIS
SINUS · Godin · Arago · Firmicus · MARE
MEDII · Ritter · Taruntius · UNDARUM
0° · Rhaeticus · Sabine · Apollonius
Flammarion · Delambre · 30° · 60° · MARE
SPUMANS · E
Herschel · Hypatia · Torricelli · A · · Messier
Ptolemaeus · Hipparchus · Capella · MARE
Albategnius · Isidorus · Gutenberg · FECUNDITATIS
Alphonsus · Theophilus · Mädler · Goclenius · Langrenus
Abulfeda · Cyrillus · MARE · Kapteyn
Argelander · NECTARIS
Arzachel · Airy · Almanon · Tacitus · Catharina · Colombo · Vendelinus
Abenezra · Geber · Beaumont
Thebit · La Caille · Playfair · Azophi · Fracastorius
Purbach · Blanchinus · Sacrobosco · Santbech
Regiomontanus · Apianus · Pontanus · Piccolomini · Petavius
Walther · Aliacensis · Zagut · Snellius · Humboldt · 30°
Nonius · Rabbi Levi · Reichenbach · Stevinus
Orontius · Büsching · Riccius · Furnerius
Stöfler · Buch · Metius · Rheita
Nasireddin · Maurolycus · Fabricius
Saussure · Barocius
Maginus · Licetus · Pitiscus · Vlacq
Cuvier · Baco · Hommel
Jacobi
60°
Curtius · Manzinus
Moretus
SOUTH

Eclipses in 2022

Lunar eclipses

There are two lunar eclipses in 2022, on May 16 and November 8. Both are total. The first eclipse will be completely visible (both penumbral and umbral phases) from the whole of South America. The maximum (total) phases are visible for much of North America, although the Moon will be low in the sky. West Africa will see the Moon enter the **umbra** before Moonset. The second lunar eclipse is visible primarily from the region of the Pacific Ocean. Early phases are visible from North America, but only the West Coast will see maximum eclipse come to an end before the Moon sets.

Solar eclipses

There are two partial solar eclipses in 2022. Neither are particularly striking. In the first, on April 30, 64 per cent of the Sun will be covered, with the event visible from Chile and Argentina. The second partial eclipse, on October 25, when a maximum 86 per cent of the Sun will be covered, will be visible over a wide area of Asia and Europe. The percentage of the Sun covered will be about 60 per cent in Moscow, 40 per cent in Berlin, and just 20 per cent in London.

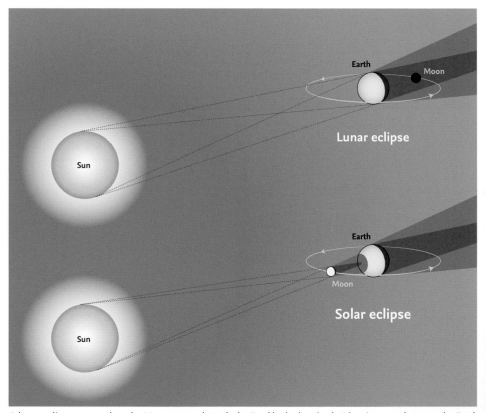

A lunar eclipse occurs when the Moon passes through the Earth's shadow (top). When it passes between the Earth and the Sun (bottom) there is a solar eclipse.

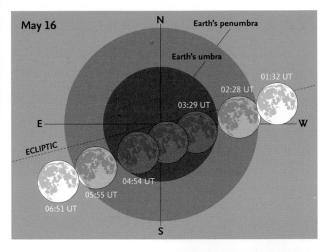

The total lunar eclipse of May 16 will be visible in its entirety from South America. Central Africa will see the Moon enter the umbra, as will western Europe, where the Moon will be low. In the United States, the total and later penumbral phases will be visible.

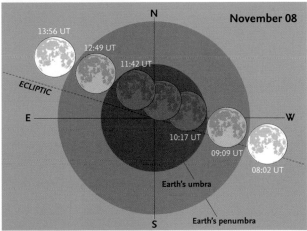

The lunar eclipse of November 8 is total, but mainly visible from the Pacific region. The Midwest of North America will see the beginning of totality, with the end visible from the West Coast. The end of the eclipse will be visible from Australia, particularly eastern Australia.

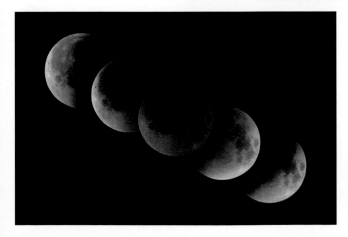

A sequence of five images of the Moon, taken by Akira Fuji, showing the progression of the Moon (from right to left: west to east) through the Earth's shadow.

The Planets in 2022

Mercury and Venus

Although **Venus** may be prominent in the sky for many months at a time, the innermost planet, **Mercury**, is readily visible only at certain elongations. Not every one is favourable. In 2022, for example, Mercury comes to greatest elongation seven times, but it is most visible at five of those only. These occasions are shown on the diagrams on this page.

Venus is prominent throughout 2022, but has a single greatest elongation on March 20, shown on the top-right diagram on this page.

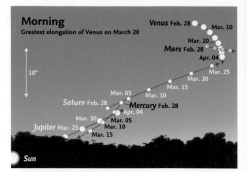

Morning
Greatest elongation of Venus on March 20

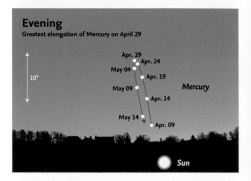

Evening
Greatest elongation of Mercury on April 29

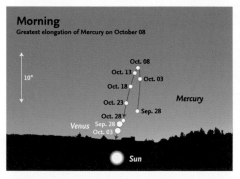

Morning
Greatest elongation of Mercury on October 08

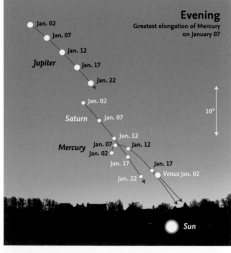

Evening
Greatest elongation of Mercury on January 07

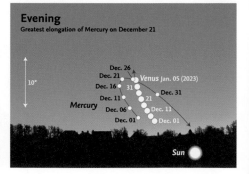

Evening
Greatest elongation of Mercury on December 21

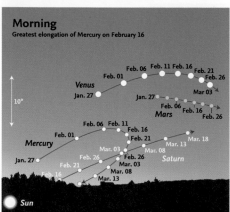

Morning
Greatest elongation of Mercury on February 16

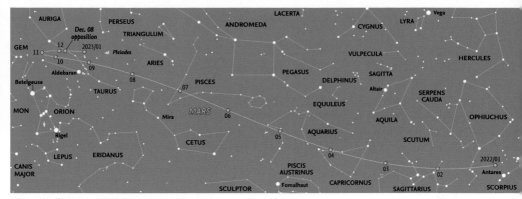

The path of Mars in 2022. Mars comes to opposition on December 8.

Mars

Because its orbit lies outside that of the Earth, so it takes longer to complete a full orbit, **Mars** does not come to opposition every year. Instead, it remains in the sky for many months at a time, moving slowly along the ecliptic. It does come to opposition in 2022, and the planet's path is shown on the large chart here. It begins the year in **Scorpius** at magnitude 1.5. It moves right across the sky, slowly brightening to mag. -1.9 at opposition on December 8 in **Taurus**, and fading to mag. -1.2 by the end of the year. Oppositions occur during a period of **retrograde motion**, when the planet appears to move westwards against the pattern of distant stars. There was no opposition in 2021. The planet begins to retrograde on 31 October 2022 and remains retrograding to the end of the year.

Because of its eccentric orbit, which carries it at very differing distances from the Sun (and Earth), not all oppositions of Mars are equally favourable for observation. The relative positions of Mars and the Earth are shown here. It will be seen that the opposition of 2018 was very close and thus favourable for observation, and that of 2020 was also reasonably good. By comparison, opposition in 2027 will be at a far greater distance, so the planet will appear much smaller.

Mars came to opposition on 13 October, 2020. This image was obtained by Damian Peach with a 14-inch Celestron telescope on September 30, when Mars was magnitude -2.5. South is at the top.

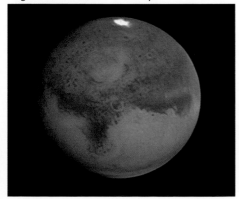

The oppositions of Mars between 2018 and 2033. In 2022, Mars comes to opposition on December 8.

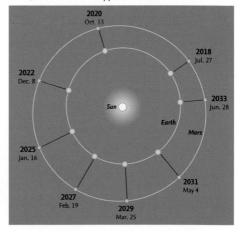

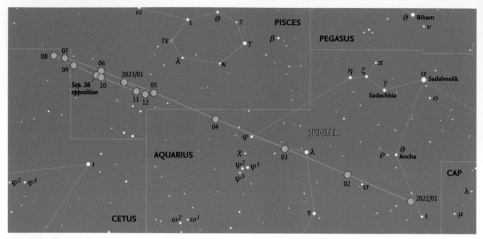

The path of Jupiter in 2022. Jupiter comes to opposition on September 26. Background stars are shown down to magnitude 6.5.

Jupiter and Saturn

In 2022, **Jupiter** and **Saturn** are in neighbouring constellations. Jupiter moves across **Aquarius**, into **Pisces** and then just into **Cetus**, where it begins to retrograde on July 29. It comes to opposition, within Pisces, on September 26, and resumes direct motion on November 26. Saturn, by contrast, remains within one constellation, **Capricornus**, retrograding from June 6 to October 23, with opposition on August 14.

Jupiter's four large satellites are readily visible in binoculars. Not all four are visible all the time, sometimes hidden behind the planet or invisible in front of it. **Io**, the closest to Jupiter, orbits in just under 1.8 days, and Callisto, the farthest away, takes about 16.7 days. In between are **Europa** (c. 3.6 days) and **Ganymede**, the largest, (c. 7.1 days). The diagram shows the satellites' motions around the time of opposition.

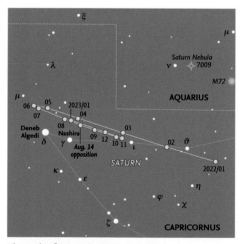

The path of Saturn in 2022. Saturn comes to opposition on August 14. Background stars are shown down to magnitude 6.5.

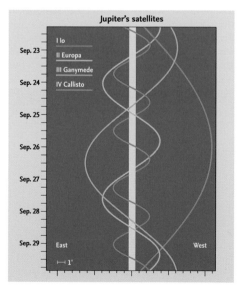

Uranus and Neptune

Uranus is in **Aries** for the whole year. Initially retrograding (at mag. 5.7), it resumes direct motion on January 22. It begins its retrograde motion on August 25. It reaches opposition (mag. 5.6) on November 9 (just after Full Moon, so observation will be difficult). It is still retrograding at the end of the year, when it is again mag. 5.7.

Neptune is in **Aquarius** for most of 2022, making an excursion into **Pisces** between May and August. Initially at mag. 7.9, it moves eastwards until June 29, when it begins to retrograde. It comes to opposition (at mag. 7.8) on September 16 (just before Last Quarter). It resumes direct motion on December 4, and ends the year at mag. 7.9.

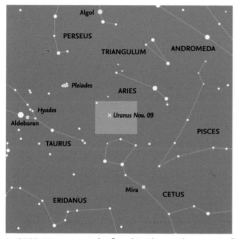

In 2022, Uranus may be found in the southern part of the constellation of Aries.

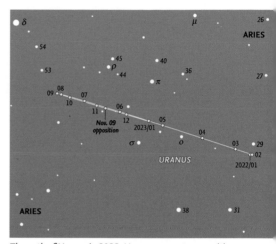

The path of Uranus in 2022. Uranus comes to opposition on November 9. All stars brighter than magnitude 7.5 are shown.

In 2022, Neptune is to be found near the boundary between Aquarius and Pisces. It comes to opposition on September 16.

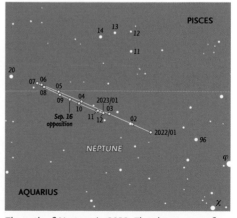

The path of Neptune in 2022. The planet moves from Aquarius into Pisces on May 1, and back into Aquarius on August 19. All stars brighter than magnitude 8.5 are shown.

Minor Planets in 2022

Several minor planets rise above magnitude 9 in 2022, but just three come to opposition. These are *(7) Iris* in *Gemini* on January 13; *(4) Vesta* in *Aquarius* on August 22; and *(3) Juno* also in *Aquarius* on September 7. The dwarf planet *(1) Ceres* is bright the whole year, reaching mag. 8.3 on December 31. *(4) Vesta* is also bright the whole year, and *(2) Pallas* is bright from early September. (3) Juno rises above mag. 9.0 in late July, before opposition, and fades below mag. 9.0 in early November.

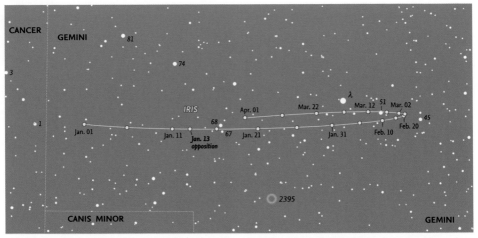

The path of the minor planet (7) Iris around its opposition on January 13 (mag. 7.6). Background stars are shown down to magnitude 9.0.

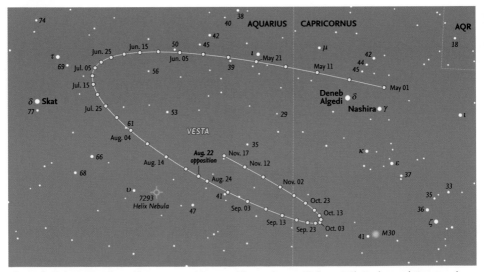

The path of the minor planet (4) Vesta around its opposition on August 22 (mag. 5.8). Background stars are shown down to magnitude 7.5.

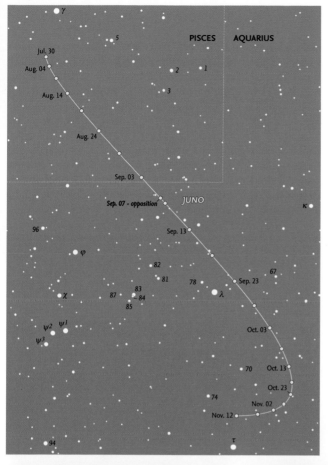

PISCES AQUARIUS

JUNO

The path of the minor planet (3) Juno around its opposition on September 7 (mag. 7.9). Background stars are shown down to magnitude 9.0.

Jul. 30
Aug. 04
Aug. 14
Aug. 24
Sep. 03
Sep. 07 - opposition
Sep. 13
Sep. 23
Oct. 03
Oct. 13
Oct. 23
Nov. 02
Nov. 12

The three charts below show the areas covered by the larger maps on these pages, in a lighter blue. The white cross shows the position of the minor planet at the day of its opposition.

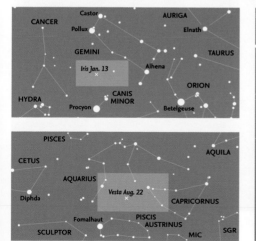

CANCER — CASTOR — Pollux — AURIGA — Elnath — GEMINI — TAURUS — Iris Jan. 13 — Alhena — ORION — HYDRA — CANIS MINOR — Procyon — Betelgeuse

PISCES — CETUS — AQUILA — AQUARIUS — CAPRICORNUS — Diphda — PISCIS AUSTRINUS — Fomalhaut — SGR — SCULPTOR — MIC — Vesta Aug. 22

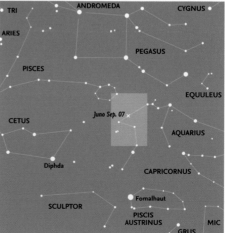

TRI — ANDROMEDA — CYGNUS — ARIES — PEGASUS — PISCES — EQUULEUS — CETUS — Juno Sep. 07 — AQUARIUS — Diphda — CAPRICORNUS — SCULPTOR — Fomalhaut — PISCIS AUSTRINUS — MIC — GRUS

Comets in 2022

Although comets may occasionally become very striking objects in the sky, as was the case with Comet C/2020 F3 NEOWISE in 2020, their occurrence and particularly the existence or length of any tail and their overall magnitude are notoriously difficult to predict. Naturally, it is only possible to predict the return of periodic comets (whose names have the prefix 'P'). Many comets appear unexpectedly (these have names with the prefix 'C'). Bright, readily visible comets such as C/1995 Y1 Hyakutake, C/1995 O1 Hale-Bopp, C/2006 P1 McNaught or C/2020 F3 NEOWISE are rare. Most periodic comets are faint and only a very small number, such as comet C/2020 M3 (ATLAS), become bright enough to be easily visible with the naked eye or with binoculars.

The comet most likely to become visible in 2022 is C/2017 K2 (PanSTARRS) which may become magnitude 9 in March and could reach magnitude 6 in June to August. Comets 19P/Borrelly and 67P/Churyumov-Gerasimenko may be faintly visible (but fading) early in the year.

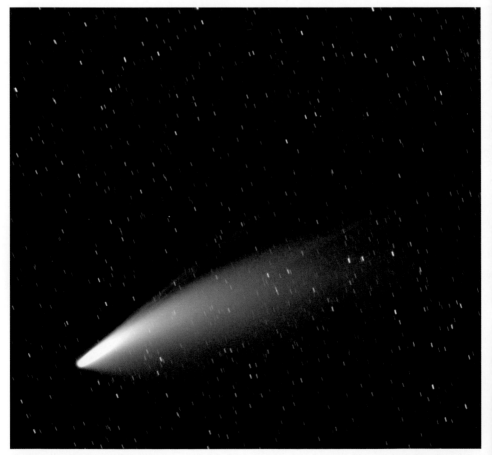

The Comet C/2020 F3 NEOWISE photographed by Nick James on 17 July 2020, showing the light-coloured dust tail, together with the blue ion tail.

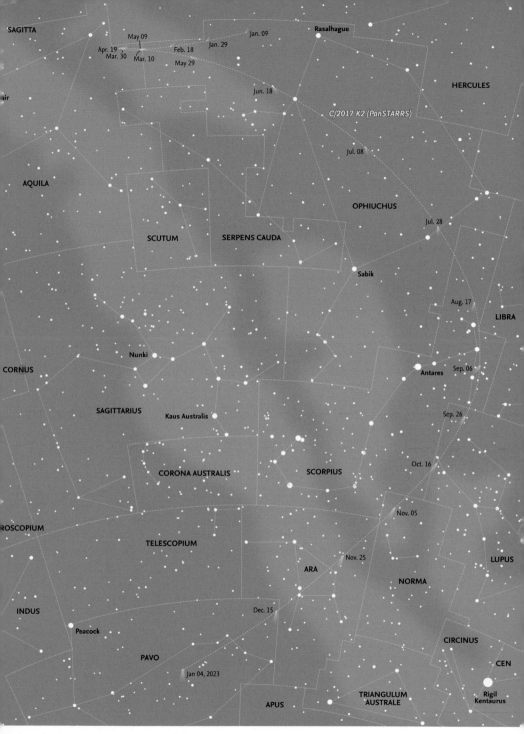

The path of comet C/2017 K2 (PanSTARRS) in 2022. Background stars are shown down to magnitude 6.5.

Introduction to the Month-by-Month Guide

The monthly charts

The pages devoted to each month contain a pair of charts showing the appearance of the night sky, looking north and looking south. The charts (as with all the charts in this book) are drawn for the latitude of 40°N, so observers farther north will see slightly more of the sky on the northern horizon, and slightly less on the southern. These areas are, of course, those most likely to be affected by poor observing conditions caused by haze, mist or smoke. In addition, stars close to the horizon are always dimmed by atmospheric absorption, so sometimes the faintest stars marked on the charts may not be visible.

The three times shown for each chart require a little explanation. The charts are drawn to show the appearance at 11 p.m. for the 1st of each month. The same appearance will apply an hour earlier (10 p.m.) on the 15th, and yet another hour earlier (9 p.m.) at the end of the month (shown as the 1st of the following month). These times are local time, and apply in all time zones. Where Daylight Saving Time (DST) is used, in 2022 it is introduced on March 13, and ends on November 6. When used, both local time and DST are shown on the charts. Times of specific events are shown in the 24-hour clock of Universal Time (UT) used by astronomers worldwide, and the correct zone time (and DST, where appropriate) may be found from the details inside the front cover.

The charts may be used for earlier or later times during the night. To observe two hours earlier, use the charts for the preceding month; for two hours later, the charts for the next month.

Meteors

Details of specific meteor showers are given in the months when they come to maximum, regardless of whether they begin or end in other months. Note that not all the respective radiants are marked on the charts for that

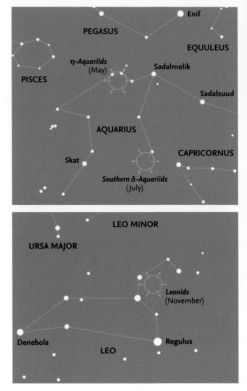

particular month, because the radiants may be below the horizon, or lie in constellations that are not readily visible during the month of maximum. For this reason, special charts for the Eta (η) and Delta (δ) Aquariids (May and July, respectively) and the Leonids (November) are shown above. As explained earlier, however, meteors from such showers may still be seen, because the most effective region for seeing meteors is some 40°–45° away from the radiant, and that area of sky may well be above the horizon. A table of the best meteor showers visible during the year is also given here. The rates given are based on the properties of the meteor streams, and are those that an experienced observer might see under ideal conditions. Generally, the observed rates will be far less.

Shower	Dates of activity 2022	Date of maximum 2022	Possible hourly rate
Quadrantids	December 28 to January 12	January 3–4	110
April Lyrids	April 14–30	April 22–23	18
η-Aquariids	April 19 to May 28	May 6	50
α-Capricornids	July 3 to August 15	July 30	5
Southern δ-Aquariids	July 12 to August 23	July 30	25
Perseids	July 17 to August 24	August 12–13	100
α-Aurigids	August 28 to September 5	September 1	6
Southern Taurids	September 10 to November 20	October 10–11	5
Orionids	October 2 to November 7	October 21–22	25
Draconids	October 6–10	October 8–9	10
Northern Taurids	October 20 to December 10	November 12–13	5
Leonids	November 6–30	November 17–18	10
Geminids	December 4–20	December 14–15	150
Ursids	December 17–26	December 22–23	10

Meteors that are brighter than magnitude -4 (approximately the maximum magnitude reached by Venus) are known as *fireballs* or *bolides*. Examples are shown on pages 32, 35 and 77. Fireballs sometimes cause sonic booms that may be heard some time after the meteor is seen.

The photographs
As an aid to identification – especially as some people find it difficult to relate charts to the actual stars they see in the sky – one or more photographs of constellations visible in certain specific months are included. It should be noted, however, that because of the limitations of the photographic and printing processes, and the differences between the sensitivity of different individuals to faint starlight (especially in their ability to detect different colors), and the degree to which they have become adapted to the dark, the apparent brightness of stars in the photographs will not necessarily precisely match that seen by any one observer.

The Moon calendar
The Moon calendar is largely self-explanatory. It shows the phase of the Moon for every day of the month, with the exact times (in Universal Time) of New Moon, First Quarter, Full Moon and Last Quarter. Because the times are calculated from the Moon's actual orbital parameters, some of the times shown will, naturally, fall during daylight, but any difference is too small to affect the appearance of the Moon on that date. Also shown is the *age* of the Moon (the day in the *lunation*), beginning at New Moon, which may be used to determine the best time for observation of specific lunar features.

The Moon
The section on the Moon includes details of any lunar or solar eclipses that may occur during the month (visible from anywhere on Earth). Similar information is given about any important occultations. Mainly, however, this section summarizes when the Moon passes close to planets or the five prominent stars close to the ecliptic. The dates when the Moon is closest to the Earth (at *perigee*) and farthest from it (at *apogee*) are shown in the monthly calendars, and only mentioned here when they are particularly significant, such as the nearest and farthest during the year.

The planets and minor planets
Brief details are given of the location, movement and brightness of the planets from Mercury to Saturn throughout the month. None of the planets can, of course, be seen when they are close to the Sun, so such periods are generally noted. All of the planets may sometimes lie on the opposite side of the Sun to the Earth (at superior conjunction), but

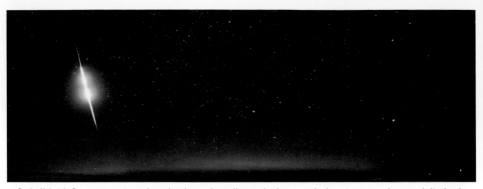

A fireball (with flares approximately as bright as the Full Moon), photographed against a weak auroral display by D. Buczynski from Tarbat Ness in Scotland on 22 January 2017.

in the case of the inferior planets, Mercury and Venus, they may also pass between the Earth and the Sun (at inferior conjunction) and are normally invisible for a period of time, the length of which varies from conjunction to conjunction. Those two planets are normally easiest to see around either eastern or western elongation, in the evening or morning sky, respectively. Not every elongation is favorable, so although every elongation is listed, only those where observing conditions are favorable are shown in the individual diagrams of events.

The dates at which the superior planets reverse their motion (from direct motion to *retrograde*, and retrograde to direct) and of opposition (when a planet generally reaches its maximum brightness) are given. Some planets, especially distant Saturn, may spend most or all of the year in a single constellation. Jupiter and Saturn are normally easiest to see around opposition, which occurs every year. Mars, by contrast, moves relatively rapidly against the background stars and in some years never comes to opposition.

Uranus is normally magnitude 5.7–5.9, and thus at the limit of naked-eye visibility under exceptionally dark skies, but bright enough to be readily visible in binoculars. Because its orbital period is so long (over 84 years), Uranus moves only slowly along the ecliptic, and often remains within a single constellation for a whole year. The chart on page 25 shows its position during 2022.

Similar considerations apply to Neptune, although it is always fainter (generally magnitude 7.8–8.0), still visible in most binoculars. It takes about 164.8 years to complete one orbit of the Sun. As with Uranus, it frequently spends a complete year in one constellation. Its chart is also on page 25.

In any year, few minor planets ever become bright enough to be detectable in binoculars. Just one, (4) Vesta, on rare occasions brightens sufficiently for it to be visible to the naked eye. Our limit for visibility is magnitude 9.0 and details and charts are given for those objects that exceed that magnitude during the year, normally around opposition. To assist in recognition of a planet or minor planet as it moves against the background stars, the latter are shown to a fainter magnitude than the object at opposition. Minor-planet charts for 2022 are on pages 26 and 27.

The ecliptic charts

Although the ecliptic charts are primarily designed to show the positions and motions of the major planets, they also show the motion of the Sun during the month. The light-tinted area shows the area of the sky that is invisible during daylight, but the darker area gives an indication of which constellations are likely to be visible at some time of the night. The closer a planet is to the border between dark and light, the more difficult it will be to see in the twilight.

The monthly calendar

For each month, a calendar shows details of significant events, including when planets are close to one another in the sky, close to the Moon, or close to any one of five bright stars that are spaced along the ecliptic. The times shown are given in Universal Time (UT), always used by astronomers throughout the year. The tables given inside the front cover may be used to convert UT to that used in any given time zone and (during the summer) to DST.

The diagrams of interesting events

Each month, a number of diagrams show the appearance of the sky when certain events take place. However, the exact positions of celestial objects and their separations greatly depend on the observer's position on Earth. When the Moon is one of the objects involved, because it is relatively close to Earth, there may be very significant changes from one location to another. Close approaches between planets or between a planet and a star are less affected by changes of location, which may thus be ignored.

The diagrams showing the appearance of the sky are drawn for the latitude of 40°N and 90°W, northwest of Springfield, IL, so will be approximately correct for most of North America. However, for an observer farther north (say, Vancouver), a planet or star listed as being north of the Moon will appear even farther north, whereas one south of the Moon will appear closer to it – or may even be hidden (occulted) by it. For an observer at a latitude of less than 40°N, there will be corresponding changes in the opposite direction: for a star or planet south of the Moon, the separation will increase, and for one north of the Moon, the separation will decrease. This is particularly important when occultations occur, which may be visible from one location, but not another. However, there are no major occultations visible in 2022.

Ideally, details should be calculated for each individual observer, but this is obviously impractical. In fact, positions and separations are actually calculated for a theoretical observer located at the center of the Earth.

So the details given regarding the positions of the various bodies should be used as a guide to their location. A similar situation arises with the times that are shown. These are calculated according to certain technical criteria, which need not concern us here. However, they do not necessarily indicate the exact time when two bodies are closest together. Similarly, dates and times are given, even if they fall in daylight, when the objects are likely to be completely invisible. However, such times do give an indication that the objects concerned will be in the same general area of the sky during both the preceding and the following nights.

Data used in this Guide

The data given in this Guide, such as timings and distances between objects, have been computed with a program developed by the US Naval Observatory in Washington D.C., widely regarded as the most accurate computation. As such, the data may differ slightly from information given elsewhere.

Key to the symbols used on the monthy star maps.

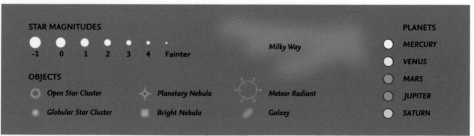

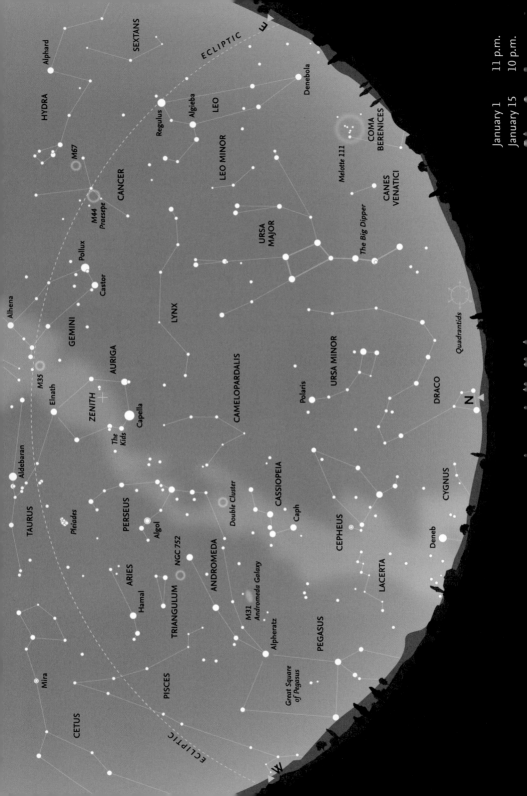

January – Looking North

Most of the important circumpolar constellations are easy to see in the northern sky at this time of year. **Ursa Major** stands more-or-less vertically above the horizon in the northeast, with the zodiacal constellation of **Leo** rising in the east. To the north, the stars of **Ursa Minor** lie below **Polaris** (the Pole Star). The head of **Draco** is low on the northern horizon, but may be difficult to see unless observing conditions are good. Both **Cepheus** and **Cassiopeia** are readily visible in the northwest, and even the faint constellation of **Camelopardalis** is high enough in the sky for it to be easily visible.

Near the zenith is the constellation of **Auriga** (the Charioteer), with brilliant **Capella** (α Aurigae), directly overhead. Slightly to the west of Capella lies a small triangle of fainter stars, known as "The Kids." (Ancient mythological representations of Auriga show him carrying two young goats.) Together with the northernmost bright star in **Taurus**, **Elnath** (β Tauri), the body of Auriga forms a large pentagon on the sky, with The Kids lying on the western side. Farther down toward the west are the constellations of **Perseus** and **Andromeda**, and the Great Square of **Pegasus** is approaching the horizon.

Meteors

One of the strongest and most consistent meteor showers of the year occurs in January: the **Quadrantids**, which are visible December 28 to January 12. They are brilliant, bluish and yellowish-white meteors and fireballs, which at maximum may even reach a rate of 120 meteors per hour. It comes to maximum on the night of January 3–4, just after New Moon, so moonlight will not cause great interference. The parent object is minor planet 2003 EH$_1$.

The shower is named after the former constellation **Quadrans Muralis** (the Mural Quadrant), an early form of astronomical instrument. The Quadrantid meteor radiant, marked on the chart, is

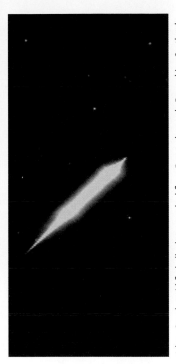

A late Quadrantid fireball, photographed from Portmahomack, Ross-shire, Scotland on 15 January 2018 at 23:44 UT.

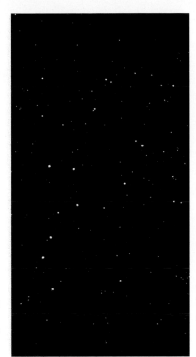

Ursa Major, the key constellation to navigating the northern sky.

now within the northernmost part of **Boötes**, roughly halfway between θ Boötis and τ Herculis. This is very low on the northern horizon, roughly halfway between **Alioth**, the last star in the "handle" of the **Big Dipper** and the head of **Draco**.

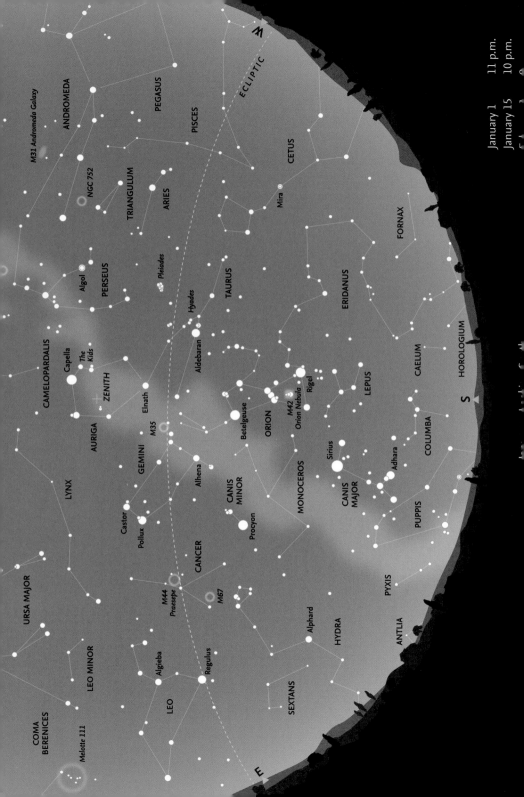

January 1 11 p.m.
January 15 10 p.m.

January – Looking South

The southern sky is dominated by *Orion*, prominent during the winter months, visible at some time during the night. It is highly distinctive, with a line of three stars that form the "Belt." To most observers, the bright star *Betelgeuse* (α Orionis), shows a reddish tinge, in contrast to the brilliant bluish-white *Rigel* (β Orionis). The three stars of the belt lie directly south of the celestial equator. A vertical line of three "stars" forms the "Sword" that hangs south of the Belt. With good viewing, the central "star" appears as a hazy spot, even to the naked eye, and is actually the *Orion Nebula*. Binoculars reveal the four stars of the Trapezium, which illuminate the nebula.

Orion's Belt points up to the northwest toward *Taurus* and orange-tinted *Aldebaran* (α Tauri). Close to Aldebaran, there is a conspicuous "V" of stars, called the *Hyades* cluster. (Despite appearances, Aldebaran is not part of the cluster.) Farther along, the same line from Orion passes below a bright cluster of stars, the *Pleiades*, or Seven Sisters. Even the smallest pair of binoculars reveals this as a beautiful group of bluish-white stars. The two most conspicuous of the other stars in Taurus lie directly above Orion, and form an elongated triangle with Aldebaran. The northernmost, *Elnath* (α Tauri), was once considered to be part of the constellation of *Auriga*.

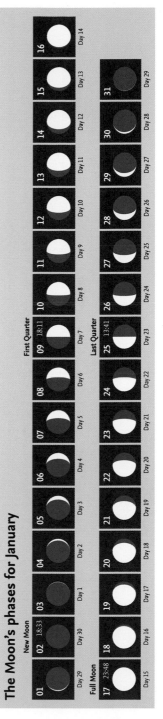

The constellation of Orion dominates the sky during this period of the year, and is a useful starting point for recognizing other constellations in the southern sky. Here, orange Betelgeuse, blue-white Rigel and the pinkish Orion Nebula are prominent. Orion can be found in the southern part of the sky (see page 36).

The Moon's phases for January

						New Moon		First Quarter							
01	02 18:33	03	04	05	06	07	08	09 18:11	10	11	12	13	14	15	16
Day 29	Day 30	Day 1	Day 2	Day 3	Day 4	Day 5	Day 6	Day 7	Day 8	Day 9	Day 10	Day 11	Day 12	Day 13	Day 14
								Last Quarter							
17 23:48	18	19	20	21	22	23	24	25 13:41	26	27	28	29	30	31	
Full Moon															
Day 15	Day 16	Day 17	Day 18	Day 19	Day 20	Day 21	Day 22	Day 23	Day 24	Day 25	Day 26	Day 27	Day 28	Day 29	

January – Moon and Planets

The Earth

The Earth reaches perihelion (the closest point to the Sun in its yearly orbit) on January 4 at 06:55 Universal Time, when its distance is 0.983336540 AU (147,105,052.565 km).

The Moon

On January 3, the Moon passes 7.5° south of **Venus** and on January 4, 3.1° south of **Mercury**, followed, later that day, 4.2° south of **Saturn**. The first of these events is very close to the Sun and difficult to see. On January 6, the Moon, a waxing crescent in the evening sky, is 4.5° south of **Jupiter** in **Aquarius**. On January 11, two days after First Quarter, the Moon passes 1.5° south of **Uranus** in **Aries**. On January 14, waxing gibbous, three days before Full Moon, it is 6° north of **Aldebaran** in **Taurus**. On January 17

(Full Moon), it is 2.6° south of **Pollux**. By January 20, it is in **Leo**, passing 4.9° north of **Regulus** and between it and **Algieba**. On January 24, the Moon is 5.5° north of **Spica**, and on January 27 it passes 3.7° north of Antares. Two days later (January 29) it is 2.4° south of **Mars.**

The planets

Mercury and **Venus** are close to the Sun and largely lost in twilight. **Mars** at mag. 1.4, initially in **Ophiuchus**, moves into **Sagittarius** and is difficult to see in the morning twilight. **Jupiter** is visible in the morning sky in **Aquarius** at mag. -2.1. **Saturn** is in **Capricornus** and too close to the Sun to be easily visible. **Uranus** is mag. 5.7 in **Aries**, resuming direct motion on January 22, and **Neptune** is mag. 7.9 in **Pisces**. On January 13, the minor planet **(7) Iris** is at opposition in **Gemini** at mag. 7.6 (see the chart on page 26).

The path of the Sun and the planets along the ecliptic in January.

Calendar for January

01–12		Quadrantid meteor shower
01	22:55	Moon at perigee (358,033 km)
02	18:33	New Moon
03–04		Quadrantid meteor shower maximum
03	08:09	Venus 7.5°N of Moon
04	01:21	Mercury 3.1°N of Moon
04	06:55	Earth at perihelion (0.983337 AU = 147,105,053 km)
04	16:47	Saturn 4.2°N of Moon
06	00:11	Jupiter 4.5°N of Moon
07	09:46	Neptune 4.1°N of Moon
07	11:04	Mercury at greatest elongation (19.2°E, mag. –0.6)
09	00:48	Venus at inferior conjunction
09	18:11	First Quarter
11	11:27	Uranus 1.5°N of Moon
13	20:35	Minor planet (7) Iris at opposition (mag. 7.6)
14	01:35	Aldebaran 6°S of Moon
14	09:26	Moon at apogee = 405,805 km
17	16:13	Pollux 2.6°N of Moon
17	23:48	Full Moon
20	11:00	Regulus 4.9°S of Moon
23	10:28	Mercury at inferior conunction
24	13:59	Spica 5.5°S of Moon
25	13:41	Last Quarter
27	23:28	Antares 3.7°S of Moon
29	15:03	Mars 2.4°N of Moon
30	01:50	Venus 10.2°N of Moon
30	07:11	Moon at perigee = 362,252 km
31	00:18	Mercury 7.6°N of Moon

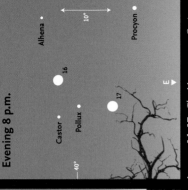

Evening 8 p.m.

January 16–17 • *The Moon passes Castor and Pollux, high in the east. Procyon and Alhena are nearby.*

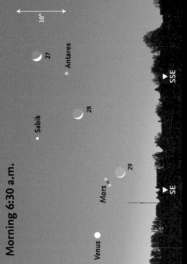

Evening 5:20 p.m.

January 3–5 • *Shortly after sunset, the narrow crescent Moon passes Mercury, Saturn and Jupiter, in the southwest. Fomalhaut is farther to the south.*

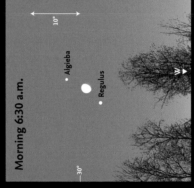

Morning 6:30 a.m.

January 27–29 • *The waning crescent Moon passes between Antares and Sabik. On January 29, it is close to Mars, with Venus farther east.*

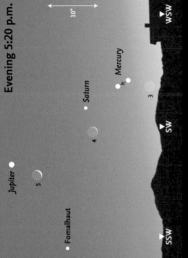

Morning 6:30 a.m.

January 20 • *In the western sky, the waning gibbous Moon is between Regulus and Algieba.*

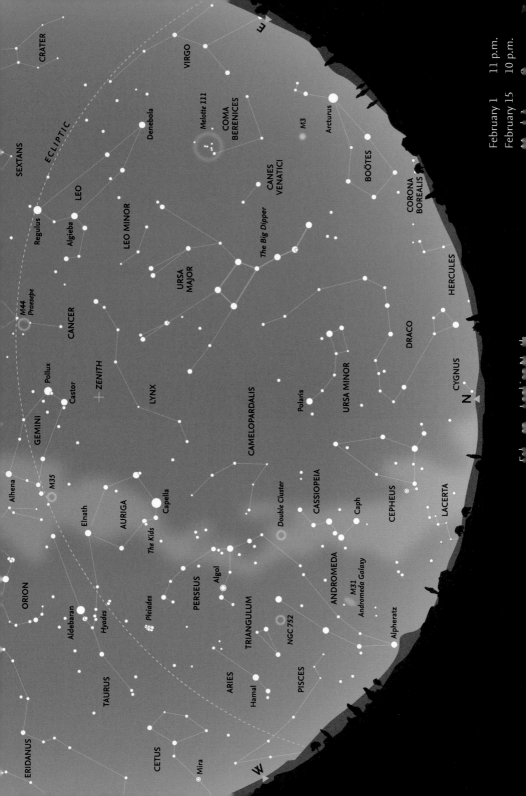

February – Looking North

The months of January and February are probably the best time for seeing the section of the Milky Way that runs in the northern and western sky from **Cygnus**, low on the northern horizon, through **Cassiopeia**, **Perseus** and **Auriga** and then down through **Gemini** and **Monoceros** (see chart on page 42). Although not as readily visible as the denser star clouds of the summer Milky Way, on a clear night so many stars may be seen that even a distinctive constellation such as Cassiopeia is not immediately obvious.

The head of **Draco** is now higher in the sky and easier to recognize. **Deneb** (α Cygni), the brightest star in **Cygnus**, is hidden below the horizon, almost due north at midnight. **Vega** (α Lyrae) in **Lyra** is so low that it is difficult to see, but may become visible later in the night. The constellation of **Boötes** – sometimes described as shaped like a kite, an ice-cream cone, or the letter "p" – with orange-tinted **Arcturus** (α Boötis), is beginning to clear the eastern horizon. Arcturus, at magnitude -0.05, is the brightest star in the northern hemisphere of the sky. The inconspicuous constellation of **Coma Berenices** is now well above the horizon in the east. The concentration of faint stars at the northwestern corner somewhat resembles a tiny, detached portion of the Milky Way. This is Melotte 111, an open star cluster (which is sometimes called the Coma Cluster, but must not be confused with the important Coma Cluster of galaxies, Abell 1656, mentioned on page 55).

On the other side of the sky, in the northwest, most of the constellation of **Andromeda** is still easily seen, although **Alpheratz** (αAndromedae), the star that forms the northeastern corner of the Great Square of Pegasus – even though it is actually part of Andromeda – is becoming close to the horizon and more difficult to detect. High overhead, at the zenith, try to make out the very faint constellation of

Lynx. It was introduced in 1687 by the famous astronomer Johannes Hevelius to fill the largely blank area between **Auriga**, **Gemini** and **Ursa Major**, and is reputed to be so named because one needed the eyes of a lynx to detect it.

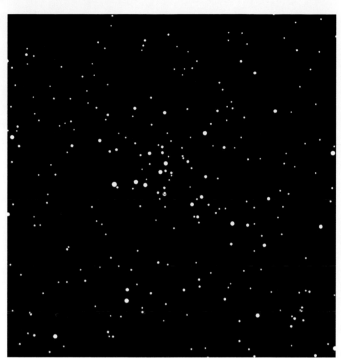

A very large, and frequently ignored, open star cluster, Melotte 111, also known as the Coma Cluster, is readily visible in the eastern sky during February.

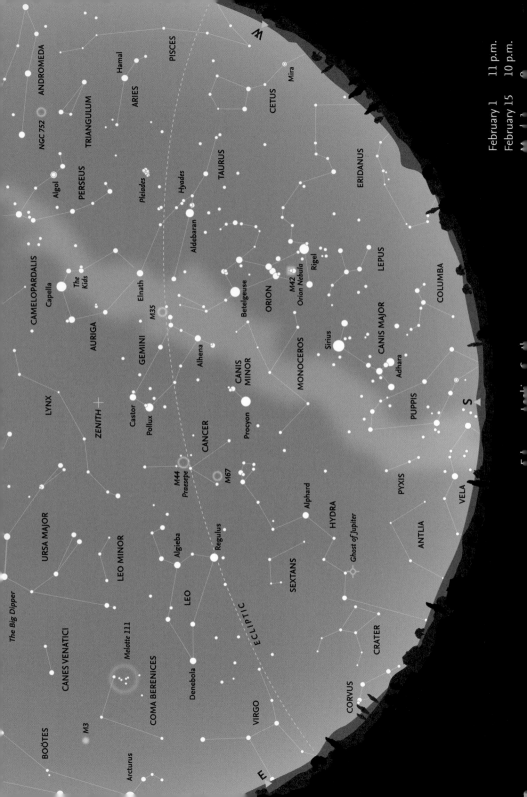

February 1 11 p.m.
February 15 10 p.m.

February – Looking South

Apart from **Orion,** the most prominent constellation visible this month is **Gemini,** with its two lines of stars running southwest toward Orion. Many people have difficulty in remembering which is which of the two stars **Castor** and **Pollux.** Castor (α Geminorum), the fainter star (mag. 1.9), is closer to the North Celestial Pole. Pollux (β Geminorum) is the brighter of the two (mag. 1.2), but is farther away from the Pole. Pollux is one of the first-magnitude stars that may be occulted by the Moon. Castor is remarkable because it is actually a multiple system, consisting of no less than six individual stars.

Orion's belt points down to the southeast toward **Sirius,** the brightest star in the sky (at magnitude -1.4) in the constellation of **Canis Major,** the whole of which is now clear of the southern horizon. Forming an equilateral triangle with **Betelgeuse** in Orion and Sirius in Canis Major is **Procyon,** the brightest star in the small constellation of **Canis Minor.** Between Canis Major and Canis Minor is the faint constellation of **Monoceros,** which actually straddles the Milky Way, which, although faint, has many clusters in this area. Directly east of Procyon is the highly distinctive asterism of six stars that form the "head" of **Hydra,** the

The constellation of Gemini. The two brightest stars, visible near the left-hand top corner of the photograph, are Castor (top) and Pollux.

largest of all 88 constellations, and which trails such a long way across the sky that it is only in mid-March around midnight that the whole constellation becomes visible.

The Moon's phases for February

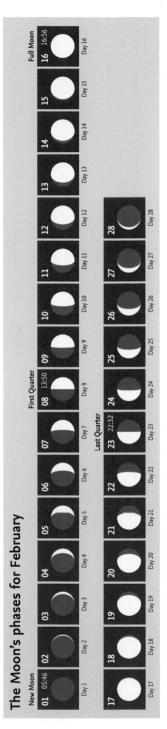

New Moon · 01 05:46 · Day 1
Day 2 · Day 3 · Day 4 · Day 5 · Day 6 · Day 7
First Quarter · 08 13:50 · Day 8
Day 9 · Day 10 · Day 11 · Day 12 · Day 13 · Day 14 · Day 15
Full Moon · 16 16:56 · Day 16
Day 17 · Day 18 · Day 19 · Day 20 · Day 21 · Day 22
Last Quarter · 23 22:32 · Day 23
Day 24 · Day 25 · Day 26 · Day 27 · Day 28

February – Moon and Planets

The Moon

Just after New Moon on February 1, the Moon passes 4.2° south of **Saturn**. The next day it is a similar distance south of **Jupiter**, low on the western horizon. On February 7 the Moon is 1.2° south of **Uranus** in **Aries**. On February 10, waxing gibbous, it is 6.7° north of **Aldebaran** in **Taurus**. On February 13 it is 2.6° south of **Pollux** in **Gemini** and just after Full Moon on February 16 it is 4.8° north of **Regulus** in **Leo**. The waning gibbous Moon is 5.3° north of **Spica** on February 20, and, one day past Last Quarter, 3.4° north of **Antares** on February 24. On February 27, a waning crescent, it is south of **Venus** and **Mars**, and these are low in the morning twilight.

Occultations

In 2022 there are no lunar occultations of the five brightest stars near the ecliptic: **Aldebaran, Antares, Pollux, Regulus** and **Spica**. There are two occultations of **Venus**, one on May 27, visible over a restricted area of the Indian Ocean only, and one on October 25, invisible in daylight. There are three occultations of **Mars**, only one visible, with difficulty, from Western Europe and North America on December 8 at Full Moon. There are no occultations of **Jupiter** or **Saturn**.

The planets

Mercury is at greatest elongation 26.3° west in the morning sky on February 16. **Venus** is in **Sagittarius**, visible in the morning sky and 7° north of **Mars** on February 13. Mars is also in Sagittarius, but becomes very low toward the end of the month and difficult to see. **Jupiter** and **Saturn** are too close to the Sun to be visible. Saturn is at superior conjunction on February 4. **Uranus** remains in **Aries** at mag. 5.8, and **Neptune** in **Aquarius** at mag. 7.9 to 8.0.

The path of the Sun and the planets along the ecliptic in February.

Calendar for February

01	05:46	New Moon
01	08:57	Saturn 4.2°N of Moon
02	21:10	Jupiter 4.3°N of Moon
03	21:13	Neptune 3.9°N of Moon
04	19:05	Saturn at superior conjunction
07	19:39	Uranus 1.2°N of Moon
08	13:50	First Quarter
10	08:53	Aldebaran 6.7°S of Moon
11	02:37	Moon at apogee = 404,897 km
13	01:00 *	Mars 7.0°S of Venus
13	23:28	Pollux 2.6°N of Moon
16	16:56	Full Moon
16	17:46	Regulus 4.8°S of Moon
16	21:07	Mercury at greatest elongation (26.3°W, mag. -0.0)
20	19:34	Spica 5.3°S of Moon
23	22:32	Last Quarter
24	05:50	Antares 3.4°S of Moon
26	22:25	Moon at perigee = 367,789 km
27	06:28	Venus 8.7°N of Moon
27	08:59	Mars 3.5°N of Moon
28	20:05	Mercury 3.7°N of Moon
28	23:45	Saturn 4.3°N of Moon

* These objects are close together for an extended period around this time.

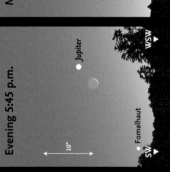

Evening 5:45 p.m.

10°

Jupiter

Fomalhaut

SW WSW

February 2 · The crescent Moon is between Jupiter and Fomalhaut, close to the southwestern horizon.

Morning 6:30 a.m.

10°

Venus

Mars

Mercury

Nunki

SE

February 13 · Mercury, Venus and Mars are in the southeast, together with Nunki.

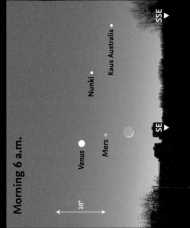

Evening 8 p.m.

10°

15

Regulus

Algieba

16

—25°

E

February 15–16 · The Moon passes between Regulus and Algieba.

Early morning 4 a.m.

10°

Acrab

Dschubba

Sabik

Antares

February 24 · In the early morning, the Moon is close to Antares, with Acrab (β Sco), Dschubba (δ Sco) and Sabik nearby.

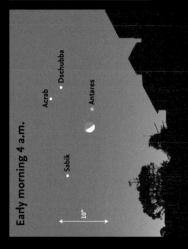

Morning 6 a.m.

10°

Venus

Mars

Nunki

Kaus Australis

SE SSE

February 27 · Venus, Mars and the crescent Moon are in the southeast. Nunki and Kaus Australis are farther south.

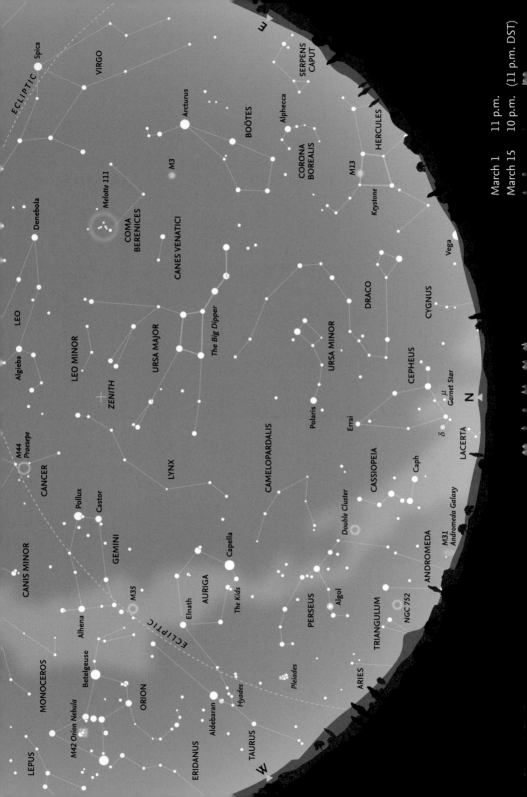

March – Looking North

The Sun crosses the celestial equator on Sunday, March 20, at the vernal equinox, when day and night are of almost equal length, and the northern season of spring is considered to begin. (The hours of daylight and darkness change most rapidly around the equinoxes in March and September.) It is also in March that Daylight Saving Time (DST) begins (on Sunday, March 13) so the charts show the appearance at 11 p.m. for March 1 and 10 p.m. for April 1. (In Europe, Summer Time is introduced two weeks later, on March 27.)

Early in the month, the constellation of **Cepheus** lies almost due north, with the distinctive "W" of **Cassiopeia** to its west. Cepheus lies across the border of the Milky Way and is often described as like the gable-end of a house and is best seen later in the night or in the month. Despite the large number of stars revealed at the base of the constellation by binoculars, one star stands out because of its deep red color. This is **µ Cephei**, also known as the Garnet Star, because of its striking color. It is a truly gigantic star, a red supergiant, and one of the largest stars known. It is about 2,400 times the diameter of the Sun, and if placed in the Solar System would extend beyond the orbit of Saturn. (Betelgeuse, in Orion, is also a red supergiant, but it is "only" about 500 times the diameter of the Sun.)

Another famous, and very important star in Cepheus is **δ Cephei**, which is the prototype for the class of variable stars known as Cepheids. These giant stars show a regular variation in their luminosity, and there is a direct relationship between the period of the changes in magnitude and the stars' actual luminosity. From a knowledge of the period of any Cepheid, its actual luminosity – known as its absolute magnitude – may be derived. A comparison of its apparent magnitude on the sky and its absolute magnitude enables the star's exact distance to be determined. Once the distances to the first Cepheid variables had been

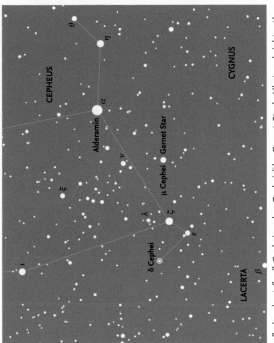

A finder chart for δ Cephei and µ Cephei (the Garnet Star). All stars brighter than magnitude 7.5 are shown. A photograph of the area is on page 49.

established, examples in more distant galaxies provided information about the scale of the universe. Cepheid variables are the first "rung" in the cosmic distance ladder. Both important stars are shown on the accompanying chart and in the photograph on page 49.

Below Cepheus to the east (to the right), late in the night, it may be possible to catch a glimpse of **Deneb** (α Cygni), just above the horizon. Slightly farther round toward the northeast, **Vega** (α Lyrae) is marginally higher in the sky. From most of the United States, Deneb is just far enough north to be seen at some time during the night (although difficult to see in January and February because it is so low). Vega, by contrast, farther south, is completely hidden during the depths of winter.

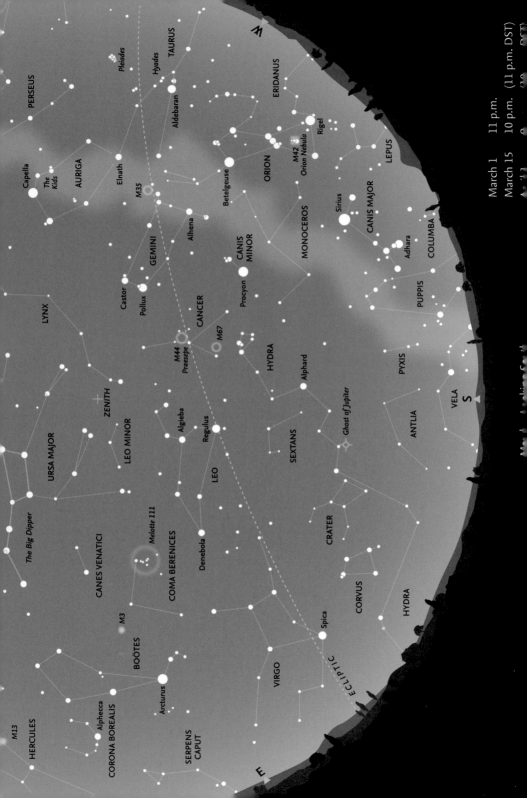

March – Looking South

Due south at 10 p.m. at the beginning of the month, lying between the constellations of *Gemini* in the west and *Leo* in the east, and fairly high in the sky above the head of Hydra, is the faint, and rather undistinguished zodiacal constellation of *Cancer*. Rather like an upside-down letter "Y," it has three "legs" radiating from the center, where there is an open cluster, M44 or *Praesepe* ("the Manger," but also known as "the Beehive"). On a clear night this cluster, known since antiquity, is just a hazy spot to the naked eye, but appears in binoculars as a group of dozens of individual stars.

Also prominent in March is the constellation of Leo, with the "backward question mark" (or "Sickle") of bright stars forming the head of the mythological lion. *Regulus* (α Leonis) – the "dot" of the "question mark" or the handle of the sickle and the brightest star in Leo – lies very close to the ecliptic and is one of the few first-magnitude stars that may be occulted by the Moon. However, there are no occultations of Regulus in 2022, nor of any of the other four bright stars near the ecliptic.

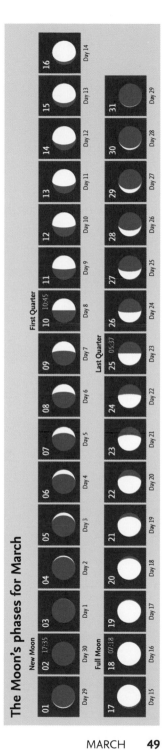

The constellation of Cepheus, with the 'W' of Cassiopeia on the left. The locations of both δ and μ Cephei are shown on the chart on page 47.

The Moon's phases for March

New Moon									
01	02 17:35	03	04	05	06	07	08	09	First Quarter 10 10:45
Day 29	Day 30	Day 1	Day 2	Day 3	Day 4	Day 5	Day 6	Day 7	Day 8
11	12	13	14	15	16				
Day 9	Day 10	Day 11	Day 12	Day 13	Day 14				
Full Moon 18 07:18	19	20	21	22	23	24	Last Quarter 25 05:37	26	27
Day 16	Day 17	Day 18	Day 19	Day 20	Day 21	Day 22	Day 23	Day 24	Day 25
17		28	29	30	31				
Day 15		Day 26	Day 27	Day 28	Day 29				

March – Moon and Planets

The Moon

On March 7, the waxing crescent Moon is 0.8° south of *Uranus* (mag. 5.8) in *Aries*. On March 9, just before First Quarter, it is 7.0° north of *Aldebaran*. On March 13, the waxing gibbous Moon passes 2.4° south of *Pollux* in *Gemini*. On March 16, two days before Full, the Moon is 4.9° north of *Regulus*. On March 20, two days after Full Moon, it is 5.1° north of *Spica* in *Virgo*. On March 23 it is 3.2° north of *Antares* in *Scorpius* and on March 28 the waning crescent Moon passes south of both *Mars* and *Venus*.

The Planets

Mercury is too close to the Sun to be seen. *Venus*, visible in the morning sky, is very bright (mag. -4.7 to -4.5) and is at western elongation on March 20. *Mars* is also in the morning sky, initially in *Sagittarius*, but moving into *Capricornus* and fading slightly to mag. 1.1. *Jupiter* is at superior conjunction in *Aquarius* on March 5, but is too close to the Sun to be visible this month. *Saturn* is in *Capricornus*, and very low in the morning sky. *Uranus* is in *Aries* at mag. 5.8. *Neptune* (mag. 8.0) is at superior conjunction on March 13.

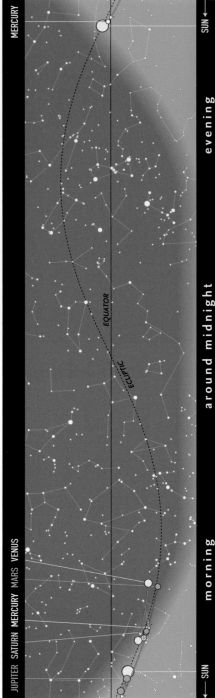

The path of the Sun and the planets along the ecliptic in March.

JUPITER SATURN MERCURY MARS VENUS

MERCURY

ECLIPTIC

EQUATOR

← SUN morning around midnight evening SUN →

Calendar for March

02	13:00 *	Mercury 0.7°S of Saturn
02	17:35	New Moon
02	18:35	Jupiter 4.1°N of Moon
03	09:02	Neptune 3.7°N of Moon
05	14:07	Jupiter at superior conjunction
07	06:08	Uranus 0.8°N of Moon
09	16:59	Aldebaran 7.0°S of Moon
10	10:45	First Quarter
10	23:04	Moon at apogee = 404,268 km
12	14:00 *	Mars 4.0°S of Venus
13		North American Daylight Saving Time begins
13	07:34	Pollux 2.4°N of Moon
13	11:43	Neptune at superior conjunction
16	02:00	Regulus 4.9°S of Moon
18	07:18	Full Moon
20	02:24	Spica 5.1°S of Moon
20	09:25	Venus at greatest elongation (46.6°W, mag. –4.5)
20	15:33	Spring (northern) equinox
23	11:16	Antares 3.2°S of Moon
23	23:37	Moon at perigee = 369,760 km
25	05:37	Last Quarter
27		European Daylight Saving Time begins (UK Summer Time)
28	02:53	Mars 4.1°N of Moon
28	09:49	Venus 6.7°N of Moon
28	11:41	Saturn 4.4°N of Moon
29	13:00 *	Saturn 2.2°S of Venus
30	14:36	Jupiter 3.9°N of Moon
30	19:18	Neptune 3.7°N of Moon

** These objects are close together for an extended period around this time.*

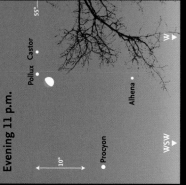

Morning 6:15 a.m.

Saturn • Mercury (ESE)
Venus
Mars
(SE)

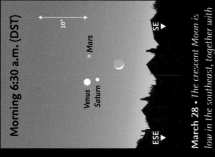

Evening 11 p.m.

Pollux Castor (55°)
Procyon (WSW)
Alhena (W)

March 2 • *Before sunrise, Venus and Mars are in the southeast. Mercury and Saturn are farther east and closer to the horizon.*

March 12 • *The Moon is close to Castor and Pollux, with Alhena directly below and Procyon farther southwest.*

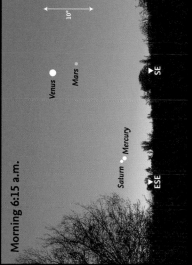

Evening 11 p.m. (DST)

Algieba (65°)
Regulus
Alphard •
(SSE)
(S)

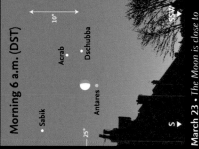

Morning 6 a.m. (DST)

Sabik • (25°)
Acrab
Antares
Dschubba
(S)
(SSW)

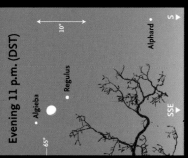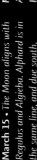

Morning 6:30 a.m. (DST)

Venus
Saturn
Mars
(ESE)
(SE)

March 15 • *The Moon aligns with Regulus and Algieba. Alphard is in the same line, and due south.*

March 23 • *The Moon is close to Antares. Sabik, Acrab (β Sco), and Dschubba (δ Sco) are nearby.*

March 28 • *The crescent Moon is low in the southeast, together with Mars, Saturn and Venus.*

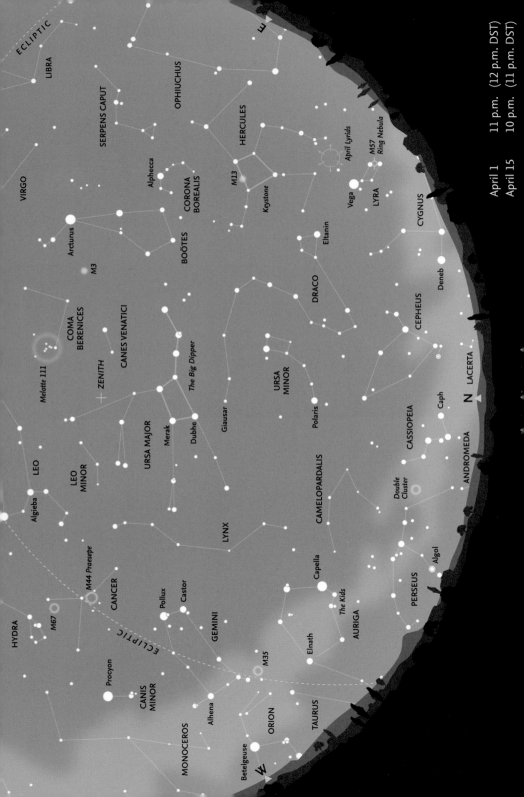

ECLIPTIC

LIBRA

SERPENS CAPUT

OPHIUCHUS

VIRGO

Alphecca

CORONA
BOREALIS

HERCULES

M13

Keystone

April Lyrids

M57
Ring Nebula

LYRA

Vega

CYGNUS

Deneb

Arcturus

M3

BOÖTES

Eltanin

DRACO

CEPHEUS

COMA
BERENICES

Melotte 111

+ ZENITH

CANES VENATICI

The Big Dipper

Giausar

URSA
MINOR

Polaris

LACERTA

N

Caph

CASSIOPEIA

ANDROMEDA

URSA MAJOR

Merak

Dubhe

Double
Cluster

LEO

Algieba

LEO
MINOR

CAMELOPARDALIS

Algol

LYNX

PERSEUS

HYDRA

M67

M44 Praesepe

CANCER

Pollux

Castor

GEMINI

Capella

The Kids

AURIGA

ECLIPTIC

Procyon

CANIS
MINOR

Alhena

Elnath

M35

TAURUS

MONOCEROS

ORION

Betelgeuse

W

	11 p.m.	(12 p.m. DST)
April 1		
	10 p.m.	(11 p.m. DST)
April 15		

April – Looking North

Cygnus and the brighter regions of the Milky Way are now starting to become visible later in the night. Rising in the northeast is the small constellation of **Lyra** and the distinctive "Keystone" of **Hercules** above it. This asterism is very useful for locating the bright globular cluster M13 (see map on page 59), which lies on one side of the quadrilateral. The winding constellation of **Draco** weaves its way from the four stars that marks its "head," on the border with Hercules, to end at λ Draconis between **Polaris** (α Ursae Minoris) and the "Pointers," **Dubhe** and **Merak** (α and β Ursae Majoris, respectively). **Ursa Major** is "upside down" high overhead, near the zenith. The constellation of **Gemini** stands almost vertically in the west. **Auriga** is still clearly seen in the northwest, but, by the end of the month, the southern portion of **Perseus** is starting to dip below the northern horizon. The very faint constellation of **Camelopardalis** lies in the northwest between Polaris and the constellations of Auriga and Perseus.

Meteors

There is one moderate meteor shower this month, the **Lyrids** (often known as the **April Lyrids**). Unfortunately, this year, the shower begins on April 14, two days before Full Moon, and comes to maximum, with a rate of just about 18 per hour, on April 22–23, two days before Last Quarter, so conditions are unfavourable. There is another, stronger shower, the **η-Aquariids**, that begins on April 19, when the Moon is waning gibbous, that continues over New Moon (April 30), and comes to maximum on May 6.

The constellation of Draco, winding round Ursa Minor, with Polaris center left.

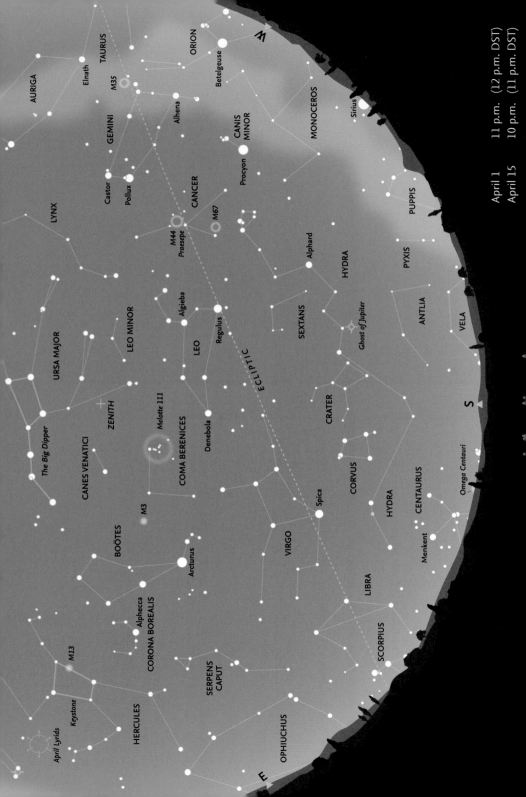

April 1 11 p.m. (12 p.m. DST)
April 15 10 p.m. (11 p.m. DST)

April – Looking South

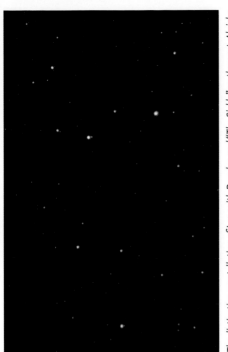

Leo is the most prominent constellation in the southern sky in April, and vaguely looks like the creature after which it is named. *Gemini*, with *Castor* and *Pollux*, remains clearly visible in the west, and *Cancer* lies between the two constellations. To the east of Leo, the whole of *Virgo*, with *Spica* (α Virginis) its brightest star, is well clear of the horizon and *Libra* is coming into view. Below Leo and Virgo, the complete length of *Hydra* is visible, running beneath both constellations, with *Alphard* (α Hydrae) halfway between Regulus and the southwestern horizon. Farther east, the two small constellations of *Crater* and the rather brighter *Corvus* lie between Hydra and Virgo. Part of *Centaurus* is now above the horizon.

Boötes and *Arcturus* are prominent in the eastern sky, together with the circlet of *Corona Borealis*, framed by Boötes and the neighbouring constellation of *Hercules*. Between Leo and Boötes lies the constellation of *Coma Berenices*, notable for being the location of the open cluster Melotte 111 (see page 41) and the Coma Cluster of galaxies (Abell 1656). There are about 1,000 galaxies in this cluster, which is located near the North Galactic Pole, where we are looking out of the plane of

The distinctive constellation of Leo, with Regulus and "The Sickle" on the west. Algieba (γ Leonis), north of Regulus, appearing double, is a multiple system of four stars.

the Galaxy and are thus able to see deep into space. Only about 10 of the brightest galaxies in the Coma Cluster are visible with the largest amateur telescopes.

The Moon's phases for April

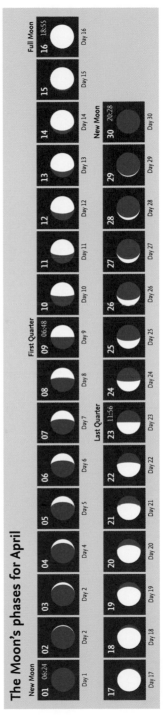

April – Moon and Planets

The Moon

On April 3, the narrow waxing crescent Moon (two days old) passes 0.6° south of **Uranus** (mag. 5.8) in **Aries** in the evening sky. On April 6, still a waxing crescent, it passes 7.2° north of orange **Aldebaran** in **Taurus**. At First Quarter on April 9, it is 2.2° south of **Pollux** in **Gemini**. It passes 5.1° north of **Regulus** on April 12 and the same distance north of **Spica** in **Virgo** on April 16. (Both events occur in daylight.) On April 19, the Moon is 3.1° north of **Antares** and on April 24, 4.5° south of **Saturn** in **Capricornus**. Two days after Last Quarter, on April 25, the Moon is 3.9° south of **Mars**. On April 27, it passes, in succession, south of **Venus, Neptune** and **Jupiter**, very low in the morning sky. On April 30, there is a partial solar eclipse, visible only from Chile and Argentina just before sunset.

The planets

Most of the planets are low in the sky this month. **Mercury** is largely invisible. It is at superior conjunction on April 2, but comes to greatest eastern elongation (20.6° from the Sun at mag. 0.2) on April 29. **Venus** is bright (mag. -4.5 to -4.1) but very low in the morning sky. **Mars** (mag. 1.1 to 0.9) moves from **Capricornus** into **Aquarius**, but is also low in the morning sky. On April 4, it is 0.3° south of **Saturn** and both are of similar magnitude (mag. 1.1 and 0.9). **Jupiter**, again very low in the morning sky (fading slightly from mag. -2.1), is initially just within **Aquarius**, and then moves into **Pisces**. **Saturn** (mag. 0.9) is in **Capricornus**. **Uranus** (mag. 5.9) is slowly moving eastwards in **Aries**. **Neptune**, in **Pisces**, is mag. 8.0 to 7.9.

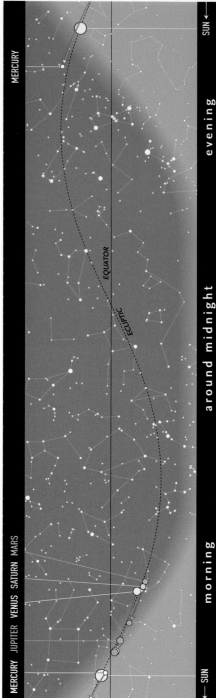

The path of the Sun and the planets along the ecliptic in April.

MERCURY JUPITER VENUS SATURN MARS

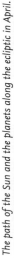

MERCURY

SUN ← morning around midnight evening → SUN

EQUATOR

ECLIPTIC

Calendar for April

01	00:25	Mercury 2.6°N of Moon
01	06:24	New Moon
02	23:11	Mercury at superior conjunction
03	17:27	Uranus 0.6°N of Moon
04	22:00 *	Mars 0.3°S of Saturn
06	01:16	Aldebaran 7.2°N of Moon
07	19:11	Moon at apogee = 404,438 km
09	06:48	First Quarter
09	15:50	Pollux 2.2°N of Moon
12	11:01	Regulus 5.1°S of Moon
12	20:00 *	Neptune 0.1°S of Jupiter
14–30		April Lyrid meteor shower
16	11:19	Spica 5.1°S of Moon
16	18:55	Full Moon
18	14:00 *	Uranus 2.1°S of Mercury
19–May.28		η-Aquariid meteor shower
19	15:13	Moon at perigee = 365,143 km
19	18:08	Antares 3.1°S of Moon
22–23		April Lyrid meteor shower maximum
23	11:56	Last Quarter
24	20:55	Saturn 4.5°N of Moon
25	22:05	Mars 3.9°N of Moon
27	01:51	Venus 3.8°N of Moon
27	03:20	Neptune 3.7°N of Moon
27	08:26	Jupiter 3.7°N of Moon
27	19:00 *	Neptune 0.01°N of Venus
29	08:09	Mercury at greatest elongation (20.6°E, mag. 0.2)
30	19:00 *	Venus 0.3°S of Jupiter
30	20:28	New Moon
30	20:41	Partial solar eclipse

* These objects are close together for an extended period around this time.

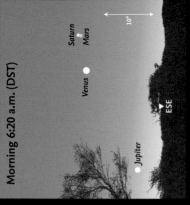

Evening 8 p.m. (DST)

April 3 • The Moon has passed Uranus. The faintest stars shown are of magnitude 5.5. Uranus is just slightly fainter (mag. 5.8). Note the different scale of this illustration.

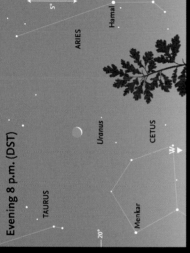

Evening 10 p.m. (DST)

April 8–9 • The Moon passes below Castor and Pollux, high in the west, with Alhena directly below and Procyon farther southwest.

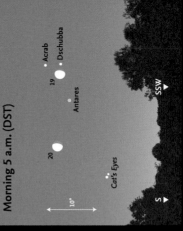

Morning 6:20 a.m. (DST)

April 5 • Venus, Saturn and Mars are close together in the morning twilight. Jupiter is closer to the horizon and farther east.

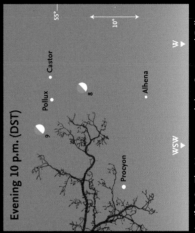

Morning 5 a.m. (DST)

April 19–20 • The Moon passes Acrab (β Sco), Dschubba (δ Sco) and Antares. The "Cat's Eyes" are closer to the horizon.

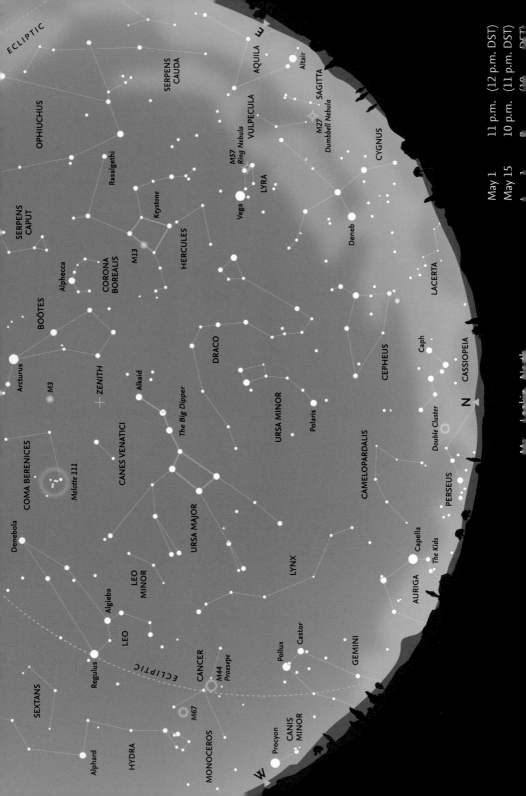

ECLIPTIC

OPHIUCHUS

SERPENS
CAUDA

AQUILA

Altair

SERPENS
CAPUT

Rasalgethi

VULPECULA

M27
Dumbbell Nebula

SAGITTA

Keystone

M57
Ring Nebula

LYRA

CYGNUS

Alphecca

M13

Vega

HERCULES

Deneb

CORONA
BOREALIS

BOÖTES

Arcturus

DRACO

LACERTA

M3

ZENITH

Alkaid

CEPHEUS

Caph

CASSIOPEIA

CANES VENATICI

The Big Dipper

URSA MINOR

N

COMA BERENICES

Melotte 111

Polaris

Double Cluster

Denebola

URSA MAJOR

CAMELOPARDALIS

PERSEUS

LEO
MINOR

LYNX

Capella

Algieba

The Kids

LEO

AURIGA

SEXTANS

Regulus

CANCER

Pollux

Castor

GEMINI

M44
Praesepe

ECLIPTIC

M67

HYDRA

MONOCEROS

Procyon

CANIS
MINOR

Alphard

May – Looking North

Cassiopeia is now low over the northern horizon and, to its west, the southern portions of both **Perseus** and **Auriga** have been lost below the horizon, although the **Double Cluster,** between Perseus and Cassiopeia is still clearly visible. The constellations of **Lyra, Cepheus, Ursa Minor** and the whole of **Draco** are well placed in the sky. **Gemini,** with **Castor** and **Pollux,** is sinking toward the western horizon. **Capella** (α Aurigae) and the asterism of **The Kids** are still just clear of the horizon.

In the east, two of the stars of the "Summer Triangle," **Vega** (α Lyrae) and **Deneb** (α Cygni), are clearly visible, and the third star, **Altair** in **Aquila,** is beginning to climb above the horizon. The whole of **Cygnus** is now visible. The sprawling constellation of **Hercules** is high in the east and the brightest globular cluster in the northern hemisphere, M13, is visible to the naked eye on the western side of the asterism known as the **Keystone.**

Three faint constellations may be identified before the lighter nights of summer make them difficult objects. Below Cepheus, low in the northeastern sky is the zig-zag constellation of **Lacerta,** while to the west, above Perseus and Auriga is **Camelopardalis** and, farther west, the line of faint stars forming **Lynx.**

Later in the night (and in the month) the westernmost stars of **Pegasus** begin to come into view, while the stars of **Andromeda** start to appear on the northeastern horizon. High overhead, **Alkaid** (η Ursae Majoris), the last star in the "tail" of the Great Bear, is close to the zenith, while the main body of the constellation has swung round into the western sky.

Meteors

The **η-Aquariids** are one of the two meteor showers associated with Comet 1P/Halley (the other being the Orionids, in October). The η-Aquariids are not particularly favourably placed for northern-

hemisphere observers, because the radiant is near the celestial equator, near the "Water Jar" in Aquarius, well below the horizon until late in the night (around dawn). However, meteors may still be seen in the eastern sky even when the radiant is below the horizon. There is a radiant map for the η-Aquariids on page 30.

Their maximum in 2022, on May 6, occurs when the Moon is a waxing crescent, so conditions are reasonably favourable. Maximum hourly rate is about 50 per hour and a large proportion (about 25 per cent) of the meteors leave persistent trains.

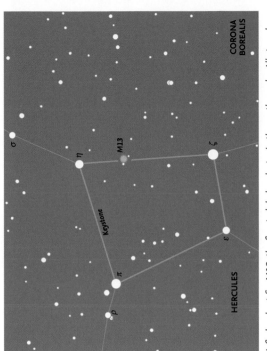

A finder chart for M13, the finest globular cluster in the northern sky. All stars down to magnitude 7.5 are shown.

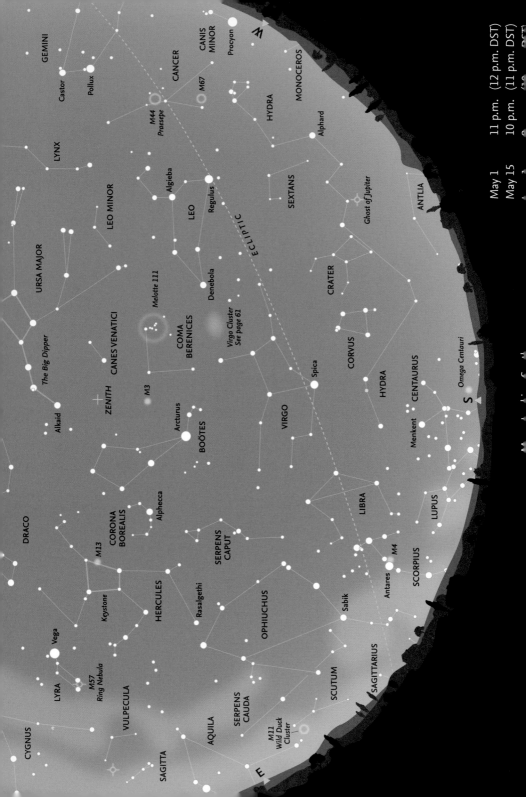

GEMINI
CANIS MINOR
Procyon
CANCER
M67
M44 *Praesepe*
HYDRA
MONOCEROS
Alphard
LEO MINOR
LYNX
Algieba
LEO
Regulus
SEXTANS
Castor
Pollux
ECLIPTIC
ANTLIA
Ghost of Jupiter
URSA MAJOR
Melotte 111
Denebola
CRATER
Virgo Cluster
See page 61
COMA BERENICES
The Big Dipper
CANES VENATICI
Spica
CORVUS
M3
VIRGO
HYDRA
ZENITH
Alkaid
CENTAURUS
Arcturus
Omega Centauri
BOÖTES
Menkent
S
DRACO
Alphecca
LIBRA
CORONA BOREALIS
LUPUS
M13
SERPENS CAPUT
Keystone
HERCULES
Rasalgethi
SCORPIUS
M4
Antares
OPHIUCHUS
Sabik
Vega
LYRA
M57 *Ring Nebula*
VULPECULA
SAGITTARIUS
SCUTUM
CYGNUS
SERPENS CAUDA
M11 *Wild Duck Cluster*
AQUILA
SAGITTA
E

May 1 11 p.m. (12 p.m. DST)
May 15 10 p.m. (11 p.m. DST)

May – Looking South

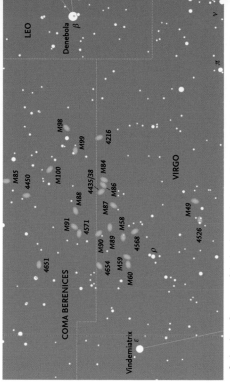

Early in the night, the constellation of *Virgo*, with *Spica* (α Virginis), lies due south, with *Leo* and both *Regulus* and *Denebola* (α and β Leonis, respectively) to its west still well clear of the horizon. The rather faint zodiacal constellation of *Libra* is now fully visible, together with most of *Scorpius* and ruddy *Antares* (α Scorpii). In the south, more of *Centaurus* may be seen, together with part of *Lupus*.

Virgo contains the nearest large cluster of galaxies, which is the center of the Local Supercluster, of which the Milky Way galaxy forms part. The Virgo Cluster contains some 2,000 galaxies, the brightest of which are visible in amateur telescopes.

Arcturus in *Boötes* is high in the south, with the distinctive circlet of *Corona Borealis* clearly visible to its east. The brightest star (α Coronae Borealis) is known as *Alphecca*. The large constellation of *Ophiuchus* (which actually crosses the ecliptic, and is thus the "13th" zodiacal constellation) is climbing into the eastern sky. Before the constellation boundaries were formally adopted by the International Astronomical Union in 1930, the southern region of Ophiuchus was regarded as

A finder chart for some of the brightest galaxies in the Virgo Cluster (see page 60). All stars brighter than magnitude 8.5 are shown.

forming part of the constellation of Scorpius, which had been part of the zodiac since antiquity.

The Moon's phases for May

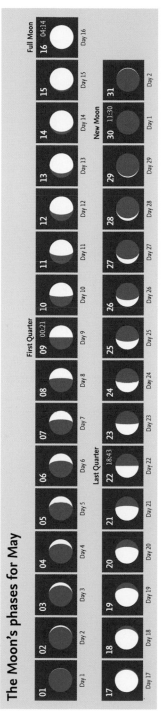

May – Moon and Planets

The Moon

On May 1, one day after New Moon, a very thin crescent Moon passes 0.4° south of *Uranus* (mag. 5.9) in *Aries*, very low in the morning sky. The Moon is 2.1° south of *Pollux* on May 6. It is 5.1° north of *Regulus* in *Leo* on May 9. On May 13, waxing gibbous, it is 5.1° north of *Spica* in *Virgo*. On May 16 there is a total lunar eclipse (see page 20). The next day, the Moon is 3.1° north of *Antares*. On May 22, at Last Quarter, it is 4.5° south of *Saturn*. Two days later it passes 2.8° south of *Mars* and then 3.3° south of *Jupiter* in *Pisces*. By May 28, a narrow waning crescent, it is just 0.3° south of *Uranus* in *Aries*.

The planets

Mercury is lost in daylight throughout May. *Venus* (mag. -4.0), in Pisces, moves closer to the Sun, becoming lost in morning twilight. There is an occultation of the planet on May 27, but this is essentially invisible, occurring in daylight and only visible from a small area of the southern Indian Ocean. *Mars* (mag. 0.9 to 0.7) moves from *Aquarius* into *Pisces*, in the morning sky. *Jupiter* (mag. -2.1 to -2.2) is also just inside Pisces. *Saturn* (mag. 0.8) is in *Capricornus*. *Uranus* is in *Aries* at mag. 5.9 and comes to superior conjunction on May 5. *Neptune* remains in *Pisces* at mag. 7.9.

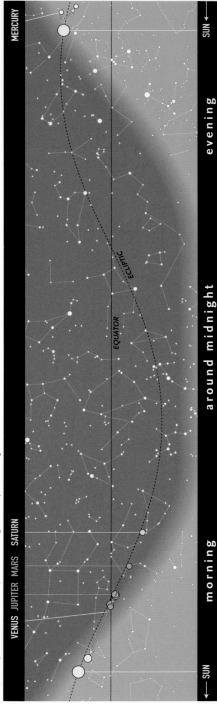

The path of the Sun and the planets along the ecliptic in May.

Calendar for May

01	04:10	Uranus 0.4°N of Moon
02	14:18	Mercury 1.9°N of Moon
03	08:57	Aldebaran 7.2°S of Moon
05	07:21	Uranus at superior conjunction
05	12:46	Moon at apogee = 405,285 km
06		η-Aquariid meteor shower maximum
06	23:32	Pollux 2.1°N of Moon
09	00:21	First Quarter
09	19:40	Regulus 5.1°S of Moon
13	21:29	Spica 5.1°S of Moon
16	04:11	Total lunar eclipse
16	04:14	Full Moon
17	03:19	Antares 3.1°S of Moon
17	15:27	Moon at perigee = 360,298 km
17	23:00 *	Neptune 0.6°N of Mars
21	19:18	Mercury at inferior conjunction
22	04:43	Saturn 4.5°N of Moon
22	18:43	Last Quarter
24	10:01	Neptune 3.7°N of Moon
24	19:23	Mars 2.8°N of Moon
25	00:02	Jupiter 3.3°N of Moon
27	02:51	Venus 0.2°N of Moon
28	13:42	Uranus 0.3°N of Moon
29	00:00 *	Mars 0.6°S of Jupiter
29	12:53	Mercury 3.7°S of Moon
30	11:30	New Moon
30	15:38	Aldebaran 7.2°S of Moon

* These objects are close together for an extended period around this time.

Morning 5:30 a.m. (DST)

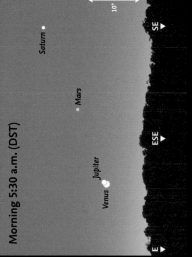

May 1 • A few hours after the actual conjunction, Venus and Jupiter rise together near the east. Mars and Saturn are much fainter and may be found farther south and higher.

Evening 10 p.m. (DST)

May 6 • The waxing crescent Moon lines up with the twin stars, Castor and Pollux.

Evening 8:30 p.m. (DST)

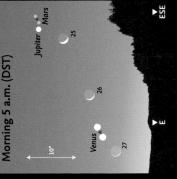

May 2 • The narrow crescent Moon lines up with Mercury and the Pleiades, which will not be easy to detect. Aldebaran is farther west.

Evening 11 p.m. (DST)

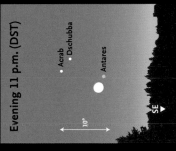

May 16 • Almost one day after Full Moon, it is close to Antares. Acrab and Dschubba are a little higher.

Morning 5 a.m. (DST)

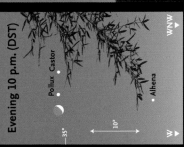

May 25–27 • Shortly before sunrise and low in the east, the waning crescent Moon passes Mars, Jupiter and Venus.

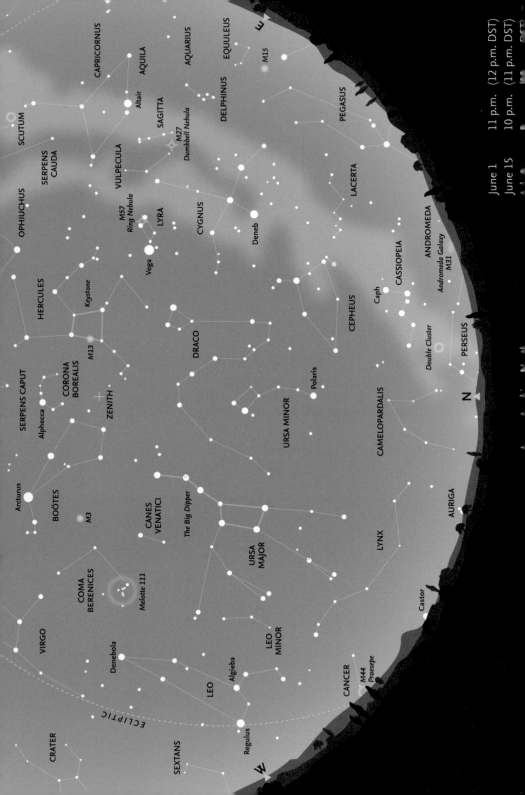

June – Looking North

With the approach of the summer solstice (June 21), twilight tends to persist in the northern United States and Canada, with four hours of darkness in Toronto in June, two hours in Seattle, and none in Vancouver. Even brighter stars, such as the seven stars making up the well-known asterism known as the *Big Dipper* in *Ursa Major* may be difficult to detect except around local midnight (1 a.m. DST). In the south of the United States, at New Orleans, Houston or Los Angeles, there are six or even seven hours of full carkness. Northern observers may have the compensation of seeing noctilucent clouds (NLC), electric-blue clouds visible during summer nights in the direction of the North Pole, for about a month or six weeks on either side of the solstice.

Two faint constellations, *Camelopardalis* and *Lynx*, may be glimpsed low on the northern and western horizons. *Leo* and *Regulus* (α Leonis) are heading downwards in the western sky, but *Cassiopeia*, farther east, is low, but clearly visible. The stars of the "Summer Triangle" (*Vega*, *Deneb* and *Altair*) in the constellations of *Lyra*, *Cygnus* and *Aquila*, respectively, are now readily seen in the east, and the small, distinctive constellation of *Delphinus* is well clear of the horizon.

Noctilucent clouds, photographed by Alan Tough from Nairn in Scotland, on 31 May 2020, at 00:28.

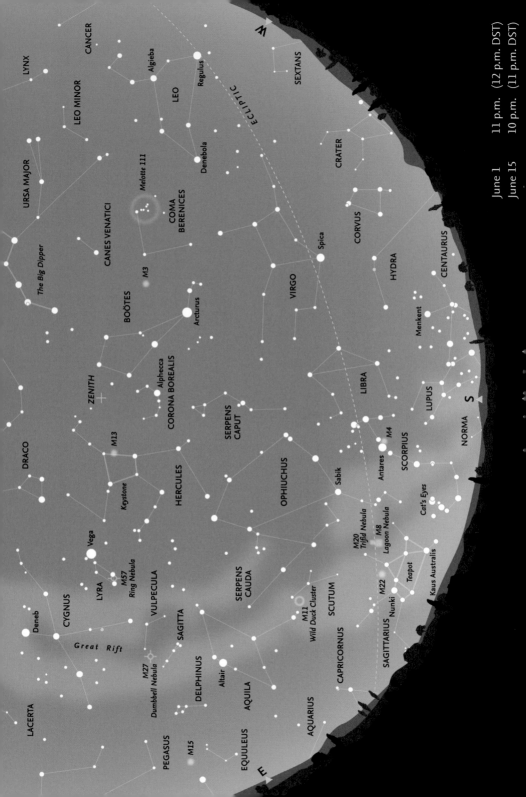

June – Looking South

The rather undistinguished constellation of *Libra* now lies almost due south. The red supergiant star *Antares* – the name means the "Rival of Mars" – in *Scorpius* is visible slightly to the east of the meridian, and even the "tail" or "sting" is visible with clear skies. Larger areas of *Centaurus* and *Lupus* are visible in the south, with *Sagittarius* to the east. Higher in the sky is the large constellation of *Ophiuchus* (the "Serpent Bearer"), lying between the two halves of *Serpens*: *Serpens Caput* ("Head of the Serpent") to the west and *Serpens Cauda* ("Tail of the Serpent") to the east. (Serpens is the only constellation to be divided into two distinct parts.) The ecliptic runs across Ophiuchus, and the Sun spends far more time in the constellation than it does in the "classical" zodiacal constellation of Scorpius, a small area of which lies between Libra and Ophiuchus.

Higher in the southern sky, the three constellations of *Boötes*, *Corona Borealis* and *Hercules* are now better placed for observation than at any other time of the year. This is an ideal time to observe the fine globular cluster of M13 in Hercules.

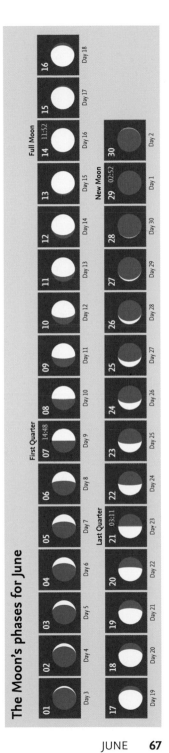

The constellations of Boötes and Corona Borealis are high in the sky in June. Arcturus has an orange tint and is the brightest star (mag. -0.05) in the northern celestial hemisphere.

The Moon's phases for June

						First Quarter									Full Moon		
01	02	03	04	05	06	07 14:48	08	09	10	11	12	13	14 11:52	15	16		
Day 19	Day 20	Day 21	Day 22	Day 23	Last Quarter Day 24	Day 25	Day 26	Day 27	Day 28	Day 29	Day 30	Day 15 New Moon	Day 16	Day 17	Day 18		
17	18	19	20	21 03:11	22	23	24	25	26	27	28	29 02:52	30				
Day 3	Day 4	Day 5	Day 6	Day 7	Day 8	Day 9	Day 10	Day 11	Day 12	Day 13	Day 14	Day 1	Day 2				

June – Moon and Planets

The Moon

On June 3, the waxing crescent Moon will be 2.1° south of **Pollux** in **Gemini**. One day before First Quarter, on June 6, it will be 5.1° north of **Regulus**. On June 10, it will be 5.0° north of **Spica** in **Virgo**. On June 13, nearly Full, and in daylight, it passes 3.1° north of **Antares**. After Full Moon on June 14, it is at the closest perigee of the year. On June 18, in daylight, it passes **Saturn** and on June 21, it is 2.7° south of **Jupiter** (again in daylight). It is 0.9° south of **Mars** the following day (June 22). As in May, it passes just south (0.1°) of Uranus on June 24. On June 26, in morning twilight, it passes 2.7° north of **Venus.** Later that day, it is 7.2° north of **Aldebaran** in **Taurus,** low in the twilight. On June 30, just after New Moon, it is 2.2° south of **Pollux.**

The planets

Mercury is at greatest western elongation (23.2°) on June 16, but too low to be readily visible. **Venus** (mag. -3.9), initially on the borders of **Pisces** and **Aries,** swiftly closes with the Sun and becomes low in the evening sky. **Mars** (mag. 0.7 to 0.5) is moving eastwards in Pisces. **Jupiter** (mag. -2.3 to -2.4) is in **Pisces. Saturn** (mag. 0.7 to 0.6) is still within **Capricornus,** but begins retrograde motion on June 6. **Uranus** is slowly moving eastwards in **Aries,** brightening very slightly from mag. 5.9 to mag. 5.8. **Neptune** remains in **Pisces** at mag. 7.9.

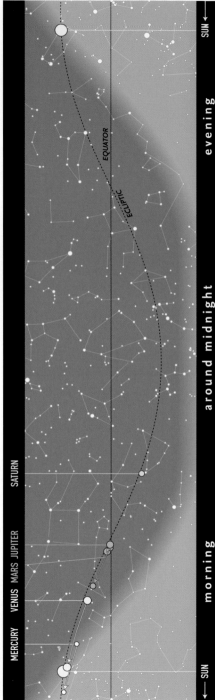

The path of the Sun and the planets along the ecliptic in June.

MERCURY	VENUS	MARS	JUPITER	SATURN

Calendar for June

02	01:13	Moon at apogee = 406,192 km
03	06:18	Pollux 2.1°N of Moon
06	03:07	Regulus 5.1°S of Moon
07	14:48	First Quarter
10	07:21	Spica 5.0°S of Moon
11	13:00 *	Uranus 1.6°N of Venus
13	13:58	Antares 3.1°S of Moon
14	11:52	Full Moon
14	23:23	Moon at perigee = 357,432 km
16	14:56	Mercury at greatest elongation (23.2°W, mag. 0.4)
18	12:22	Saturn 4.3°N of Moon
20	16:50	Neptune 3.5°N of Moon
21	03:11	Last Quarter
21	09:14	Northern summer solstice
21	13:36	Jupiter 2.7°N of Moon
22	18:16	Mars 0.9°N of Moon
24	22:13	Uranus 0.1°N of Moon
26	08:10	Venus 2.7°S of Moon
26	21:37	Aldebaran 7.2°S of Moon
27	08:18	Mercury 3.9°S of Moon
29	02:52	New Moon
29	06:08	Moon at apogee (most distant of year) = 406,580 km
30	12:22	Pollux 2.2°N of Moon

* These objects are close together for an extended period around this time.

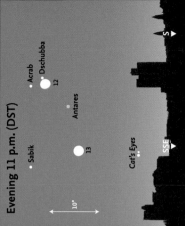

Evening 9 p.m. (DST)

June 2 • The waxing crescent Moon is close to Castor and Pollux, with Alhena directly below and Procyon farther west.

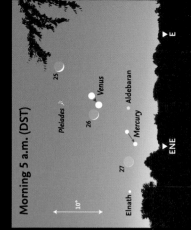

Evening 11 p.m. (DST)

June 12–13 • The almost Full Moon passes Acrab (β Sco), Dschubba (δ Sco) and Antares. The "Cat's Eyes" are closer to the horizon.

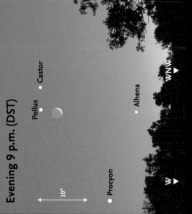

Morning 5 a.m. (DST)

June 21–22 • In the early morning, the Moon passes below Jupiter and Mars in the east-southeastern sky. Diphda (β Cet) is closer to the horizon.

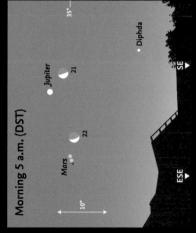

Morning 5 a.m. (DST)

June 25–27 • The waning crescent Moon passes the Pleiades, Venus and Mercury. Aldebaran and Elnath are nearby.

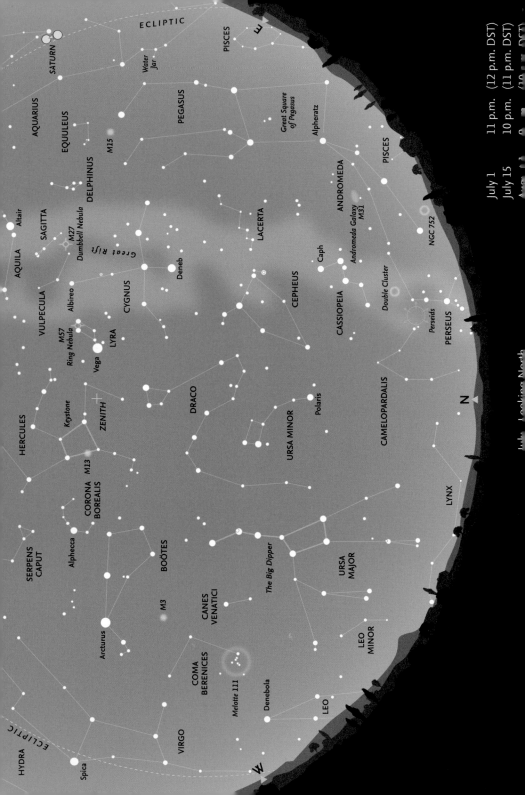

ECLIPTIC

PISCES

E

SATURN

Water
Jar

AQUARIUS

PEGASUS

EQUULEUS

PISCES

Great Square
of Pegasus

M15

Alpheratz

DELPHINUS

ANDROMEDA

Altair

SAGITTA

LACERTA

Andromeda Galaxy
M31

NGC 752

AQUILA

M27
Dumbbell Nebula

Caph

Double Cluster

VULPECULA

Great Rift

Deneb

CEPHEUS

CASSIOPEIA

Albireo

CYGNUS

Perseids

M57
Ring Nebula

Vega

LYRA

Polaris

PERSEUS

HERCULES

Keystone

DRACO

URSA MINOR

CAMELOPARDALIS

ZENITH

N

CORONA
BOREALIS

M13

Alphecca

SERPENS
CAPUT

BOÖTES

LYNX

M3

CANES
VENATICI

The Big Dipper

URSA
MAJOR

Arcturus

COMA
BERENICES

LEO
MINOR

Melotte 111

Denebola

LEO

VIRGO

W

HYDRA ECLIPTIC

Spica

July 1 11 p.m. (12 p.m. DST)
July 15 10 p.m. (11 p.m. DST)

July · Looking North

July – Looking North

As in June, light nights and the chance of observing noctilucent clouds persist throughout July, but later in the month (and particularly after midnight) some of the major constellations begin to be more easily seen. **Capella**, the brightest star in **Auriga** together with the rest of the constellation, is hidden below the northern horizon. **Cassiopeia** is clearly visible in the northeast and **Perseus**, to its south, is beginning to climb clear of the horizon. The band of the Milky Way, from Perseus through Cassiopeia toward **Cygnus**, stretches up into the northeastern sky. If the sky is dark and clear, you may be able to make out the small, faint constellation of **Lacerta**, lying across the Milky Way between Cassiopeia and Cygnus. In the east, the stars of **Pegasus** are now well clear of the horizon, with the main line of stars forming **Andromeda** roughly parallel to the horizon low in the northeast. **Alpheratz** (α Andromedae) is actually the star at the northeastern corner of the **Great Square of Pegasus**. **Cepheus** and **Ursa Major** are on opposite sides of **Polaris** and **Ursa Minor**, in the east and west, respectively. The head of **Draco** is very close to the zenith (which is in **Hercules**) so the whole of this winding constellation is readily seen.

Meteors

July brings increasing meteor activity, mainly because there are several minor radiants active in the constellations of **Capricornus** and **Aquarius**. Because of their location, however, observing conditions are not particularly favorable for northern-hemisphere observers, although the first shower, the **α-Capricornids**, active from July 3 to August 15 (peaking July 30, with a tail to August 15), does often produce very bright fireballs. The maximum rate, however, is only about 5 per hour. The parent body is Comet 169P/NEAT. The most prominent shower is probably that of the **Southern δ-Aquariids**, which are active from around July 12 to August 23, with a peak on July 30, although

Cygnus, sometimes known as the "Northern Cross," depicts a swan flying down the Milky Way toward Sagittarius. The brightest star, Deneb (α Cygni), represents the tail, and Albireo (β Cygni) marks the position of the head, and lies near the bottom of the image.

even then the rate is unlikely to reach 25 meteors per hour. In this case, the parent body may be Comet 96P/Machholz. This year, both shower maxima occur when the Moon is a thin waxing crescent, so observing conditions are not particularly favorable. A chart showing the **δ-Aquariids** radiant is shown on page 30. The **Perseids** begin on July 17 and peak on August 12–13.

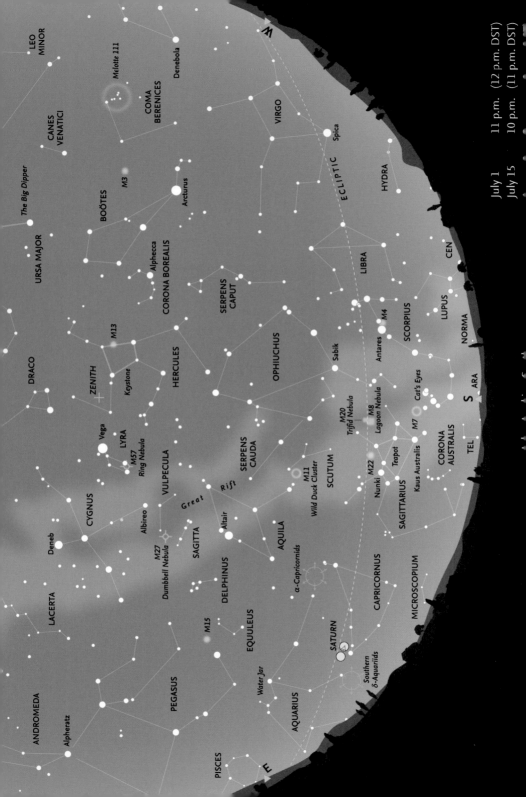

July – Looking South

This is the best time of year to see **Scorpius**, with deep red **Antares** (α Scorpii), glowing just above the southern horizon. At around midnight, part of **Sagittarius**, with the distinctive asterism of the "Teapot," and the dense star clouds of the center of the Milky Way, are visible in the south, together with the small constellation of **Corona Australis**. The **Great Rift** – actually dust clouds that hide the more distant stars – runs down the Milky Way from **Cygnus** toward Sagittarius. Toward its northern end is the small constellation of **Sagitta** and the planetary nebula **M27** (the Dumbbell Nebula) in the otherwise insignificant constellation of **Vulpecula**. The sprawling constellation of **Ophiuchus** lies close to the meridian for a large part of the month, separating the two halves of the constellation of **Serpens**. The western half is called **Serpens Caput** (Head of the Serpent) and the eastern part **Serpens Cauda** (Tail of the Serpent). In the east, the bright **Summer Triangle**, consisting of **Vega** in **Lyra**, **Deneb** in Cygnus and **Altair** in **Aquila**, begins to dominate the southern sky, as it will throughout August and into September. The small constellation of Lyra, with Vega and a distinctive quadrilateral of stars to its east and south, lies not far from the zenith.

A finder chart for M27, the Dumbbell Nebula, a relatively bright (magnitude 8) planetary nebula – a shell of material ejected in the late stages of a star's lifetime – in the constellation of Vulpecula. All stars brighter than magnitude 7.5 are shown.

The Moon's phases for July

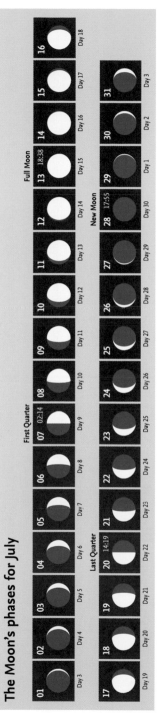

July – Moon and Planets

The Earth

The Earth reaches aphelion, the farthest point from the Sun in its yearly orbit, at 07:11 on July 4 at a distance of 1.016715374 AU (152,098,455.06 km).

The Moon

On July 3, the Moon, a waxing crescent, passes 4.9° north of **Regulus**, between it and **Algieba**. On July 7 in daylight, it is the same distance (4.9°) north of **Spica**. On July 11, two days before Full, it passes 3.0° north of **Antares**. On July 15, two days after Full Moon, it is 4.1° south of **Saturn** in **Capricornus**. By July 19, nearing Last Quarter, it is 2.2° south of **Jupiter**. On July 21 it is 1.1° north of **Mars**, and then, a day later, just 0.2° north

of **Uranus**. The Moon is 7.4° north of **Aldebaran** on July 24. It is 4.2° north of **Venus** on July 26, and, the next day, is 2.2° south of **Pollux** in **Gemini**.

The planets

Mercury, initially in **Taurus**, rapidly moves toward the Sun and comes to superior conjunction on July 16. **Venus** is also initially in Taurus and is visible in the morning sky at mag. -3.9 to -3.8. **Mars** moves from **Pisces** into **Aries**, brightening slightly from mag. 0.5 to 0.2. **Jupiter** (mag. -2.4 to -2.6) on the border of **Pisces** and **Cetus**, begins retrograde motion late in the month (on July 29). **Saturn** (mag. 0.6 to 0.4) continues retrograde motion in **Capricornus**. **Uranus** is still in **Aries** at mag. 5.8, and **Neptune** is in **Pisces** at mag. 7.9.

The path of the Sun and the planets along the ecliptic in July.

Calendar for July

02	00:00 *	Venus 4.2°N of Aldebaran
03–Aug.15		α-Capricornid meteor shower
03	09:22	Regulus 4.9°S of Moon
04	07:11	Earth at aphelion
		(1.016715 AU = 152,098,455 km)
07	02:14	First Quarter
07	15:37	Spica 4.9°S of Moon
11	00:22	Antares 3.0°S of Moon
12–Aug.23		Southern δ-Aquariid meteor
		shower
13	09:06	Moon at perigee (closest of year)
		= 357,264 km
13	18:38	Full Moon
15	20:17	Saturn 4.1°N of Moon
16	19:38	Mercury at superior conjunction
17–Aug.24		Perseid meteor shower
18	00:50	Neptune 3.3°N of Moon
19	00:59	Jupiter 2.2°N of Moon
20	14:19	Last Quarter
21	16:46	Mars 1.1°S of Moon
22	06:21	Uranus 0.2°S of Moon
24	03:36	Aldebaran 7.4°S of Moon
26	10:22	Moon at apogee = 406,274 km
26	14:11	Venus 4.2°S of Moon
27	18:21	Pollux 2.2°N of Moon
28	17:55	New Moon
29	21:07	Mercury 3.6°S of Moon
30		α-Capricornid meteor shower
		maximum
30		Southern δ-Aquariid meteor
		shower maximum
30	15:08	Regulus 4.8°S of Moon

* These objects are close together for an extended period around this time.

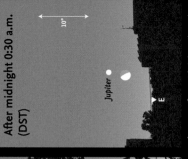

Evening 9:30 p.m. (DST)

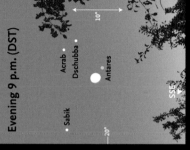

Evening 9 p.m. (DST)

July 2–3 • The crescent Moon passes between Regulus and Algieba, in the west, after sunset.

July 10 • The nearly Full Moon is close to Antares, with Acrab (β Sco), Dschubba (δ Sco) and Sabik nearby.

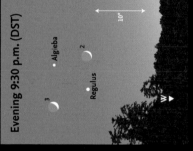

Early morning 3 a.m. (DST)

July 21–22 • The Moon passes Mars and Uranus. Background stars are shown down to magnitude 5.5. Uranus is just slightly fainter (mag. 5.8). Note the different scale of this illustration.

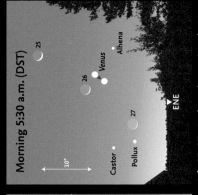

After midnight 0:30 a.m. (DST)

July 19 • After midnight, when the Moon rises in the east, it is in the company of Jupiter.

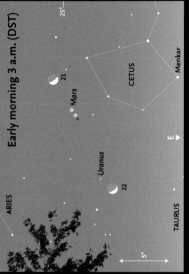

Morning 5:30 a.m. (DST)

July 25–27 • In the early morning, the Moon passes Venus and Alhena. On July 27, the narrow crescent Moon is close to Pollux.

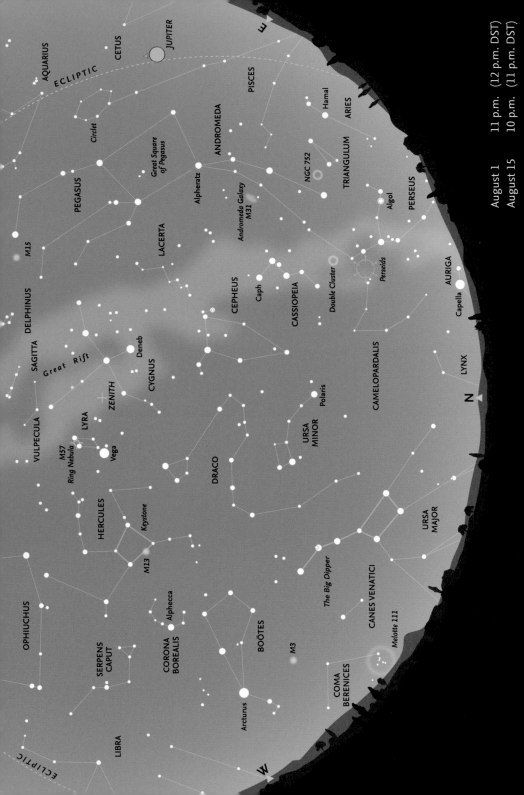

AQUARIUS
CETUS
JUPITER
ECLIPTIC
PISCES
Hamal
ARIES
ANDROMEDA
Circlet
TRIANGULUM
NGC 752
Great Square of Pegasus
Alpheratz
PEGASUS
Algol
PERSEUS
Andromeda Galaxy M31
LACERTA
M15
Perseids
Caph
Double Cluster
CASSIOPEIA
DELPHINUS
CEPHEUS
AURIGA
SAGITTA
Capella
Great Rift
Deneb
CYGNUS
CAMELOPARDALIS
VULPECULA
ZENITH
LYNX
LYRA
Polaris
N
M57
Ring Nebula
Vega
URSA MINOR
HERCULES
DRACO
Keystone
M13
URSA MAJOR
OPHIUCHUS
Alphecca
CORONA BOREALIS
The Big Dipper
SERPENS CAPUT
CANES VENATICI
BOÖTES
Melotte 111
M3
LIBRA
Arcturus
COMA BERENICES
ECLIPTIC

August 1 11 p.m. (12 p.m. DST)
August 15 10 p.m. (11 p.m. DST)

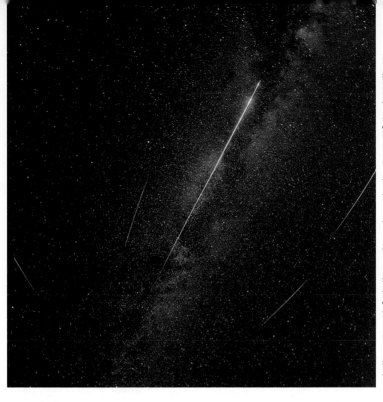

A brilliant Perseid fireball, streaking alongside the Great Rift in the Milky Way, photographed in 2012 by Jens Hackmann from near Weikersheim in Germany. Four additional, fainter Perseids are also visible in the image.

August – Looking North

Ursa Major is now the "right way up" in the northwest, although some of the fainter stars in the south of the constellation are difficult to see. Beyond it, *Boötes* stands almost vertically in the west, but pale orange *Arcturus* is sinking toward the horizon. Higher in the sky, both *Corona Borealis* and *Hercules* are clearly visible.

In the northeast, *Capella* becomes visible later in the night, but most of *Auriga* still remains below the horizon. Higher in the sky, *Perseus* is gradually coming into full view and, later in the night and later in the month, the beautiful *Pleiades* cluster rises above the northeastern horizon. Between Perseus and *Polaris* lies the faint and unremarkable constellation of *Camelopardalis*.

Higher still, both *Cassiopeia* and *Cepheus* are well placed for observation, despite the fact that Cassiopeia is completely immersed in the band of the Milky Way, as is the "base" of Cepheus. *Pegasus* and *Andromeda* are now well above the eastern horizon and, below them, the constellation of *Pisces* is climbing into view. Two of the stars in the "Summer Triangle," *Deneb* and *Vega*, are close to the zenith high overhead.

Meteors

August is the month when one of the best meteor showers of the year occurs: the *Perseids*. This is a long shower, generally beginning about July 17 and continuing until around August 24, with a maximum on August 12–13, when the rate may reach as high as 100 meteors per hour (and on rare occasions, even higher). In 2022, maximum is around Full Moon, so conditions are particularly bad. The Perseids are debris from Comet 109P/Swift-Tuttle (the Great Comet of 1862). Perseid meteors are fast and many of the brighter ones leave persistent trains. Some bright fireballs also occur during the shower.

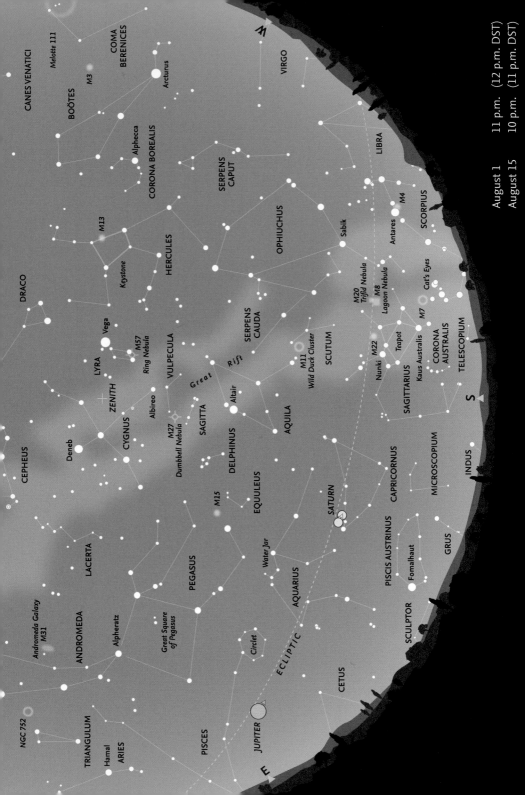

August – Looking South

The whole stretch of the summer Milky Way stretches across the sky in the south, from **Cygnus**, high in the sky near the zenith, past **Aquila**, with bright **Altair** (α Aquilae), to part of the constellation of **Sagittarius** close to the horizon, where the pattern of stars known as the "Teapot" is visible. This area contains many nebulae and both open and globular clusters. Between **Albireo** (β Cygni) and Altair lie the two small constellations of **Vulpecula** and **Sagitta**, with the latter easier to distinguish (because of its shape) from the clouds of the Milky Way. Between Sagitta and **Pegasus** to the east lie the highly distinctive five stars that form the tiny constellation of **Delphinus** (again, one of the few constellations that actually bear some resemblance to the creatures after which they are named). Below Aquila, mainly in the star clouds of the Milky Way, lies **Scutum**, most famous for the bright open cluster, **M11** or the "Wild Duck Cluster," readily visible in binoculars. To the southeast of Aquila lie the two zodiacal constellations of **Capricornus** and **Aquarius** and, farther south, the constellation of **Piscis Austrinus** with the brilliant star **Fomalhaut**.

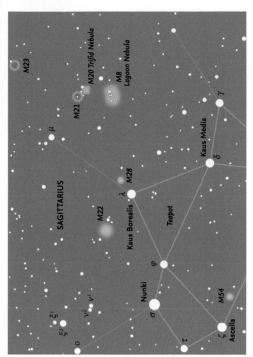

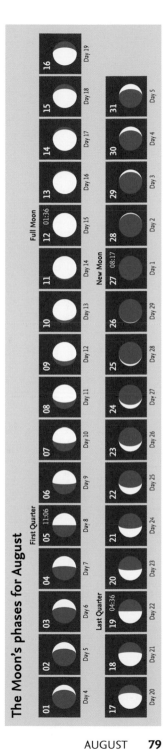

A finder chart for the gaseous nebulae M8 (the Lagoon Nebula), M20 (the Trifid Nebula) and the globular cluster M22, all in Sagittarius. Clusters M21, M23 (open) and M28 (globular) are faint. The chart shows all stars brighter than magnitude 7.5.

The Moon's phases for August

August – Moon and Planets

The Moon

On August 3, the waxing crescent Moon passes 4.6° north of **Spica** in **Virgo**. On August 7, it passes 2.8° north of **Antares**. On August 12, at Full Moon, it is 3.9° south of **Saturn**. It passes 1.9° south of **Jupiter** on August 15 and 0.6° north of **Uranus** in **Aries** on August 18. Just after Last Quarter on August 19, it is 2.7° north of **Mars** in **Taurus**, having passed the **Pleiades**. The next day, it passes 7.6° north of **Aldebaran**. On August 24, the waning crescent is 2.1° south of **Pollux**. The following day it passes 4.3° north of **Venus**. On August 26, one day before New Moon, the narrow crescent passes 4.7° north of **Regulus**. By August 31, the waxing crescent is 4.4° north of **Spica** in **Virgo**.

The planets

Mercury is low in the twilight. It comes to greatest elongation (27.3°) east at mag. 0.2, on August 27. **Venus** (mag. -3.8 to -3.9), initially in **Gemini**, rapidly moves toward the Sun and into twilight. **Mars** moves from **Aries** (at mag. 0.2) into **Taurus**, brightening to mag. -0.1. **Jupiter**, just within the top of **Cetus**, continues slow retrograde motion, slowly increasing from mag. -2.7 to mag. -2.9 over the month. **Saturn** is at opposition (mag. 0.3) in **Capricornus** on August 14. **Uranus** is still in **Aries** at mag. 5.8, and begins retrograde motion on August 25. **Neptune** retrogrades from **Pisces** into **Aquarius** at mag. 7.9. On August 22, minor planet **(4) Vesta** is at opposition in **Aquarius** at mag. 5.8 (see chart on page 26).

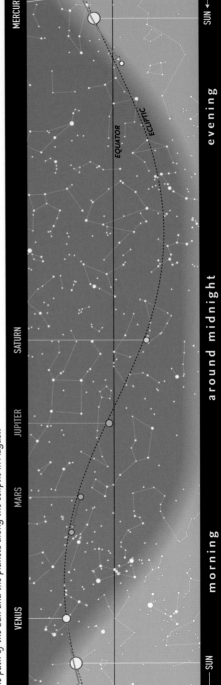

The path of the Sun and the planets along the ecliptic in August.

Calendar for August

01	09:00 *	Uranus 1.4°N of Mars
03	22:01	Spica 4.6°S of Moon
05	11:06	First Quarter
07	09:02	Antares 2.8°S of Moon
07	10:00 *	Venus 6.6°S of Pollux
10	17:09	Moon at perigee = 359,828 km
12–13		Perseid meteor shower maximum
12	01:36	Full Moon
12	03:56	Saturn 3.9°N of Moon
14	09:53	Neptune 3.1°N of Moon
14	17:10	Saturn at opposition (mag. 0.3)
15	09:42	Jupiter 1.9°N of Moon
18	14:38	Uranus 0.6°S of Moon
19	04:36	Last Quarter
19	12:17	Mars 2.7°S of Moon
20	10:24	Aldebaran 7.6°S of Moon
22	18:55	Minor planet (4) Vesta at opposition (mag. 5.8)
22	21:52	Moon at apogee = 405,418 km
24	00:53	Pollux 2.1°N of Moon
25	20:57	Venus 4.3°S of Moon
26	21:25	Regulus 4.7°S of Moon
27	08:17	New Moon
27	16:14	Mercury at greatest elongation (27.3°E, mag. 0.2)
28–Sep.05		α-Aurigid meteor shower
29	10:51	Mercury 6.6°S of Moon
31	03:35	Spica 4.4°S of Moon

* These objects are close together for an extended period around this time.

Early morning 3 a.m. (DST)

August 1 • Mars is close to Uranus (mag. 5.8). The faintest stars shown here are of magnitude 5.5. Note the different scale of this illustration.

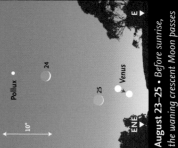

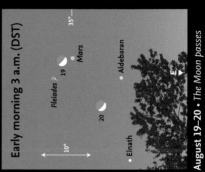

Morning 5:30 a.m. (DST)

August 7 • Shortly before sunrise, Venus is close to Castor and Pollux. Alhena is farther east.

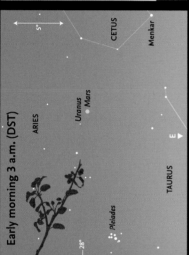

Morning 5 a.m. (DST)

August 15 • The waning gibbous Moon is close to Jupiter. Diphda (β Cet) is closer to the horizon.

Early morning 3 a.m. (DST)

August 19–20 • The Moon passes Mars, the Pleiades and Aldebaran, high in the east.

Morning 5:45 a.m. (DST)

August 23–25 • Before sunrise, the waning crescent Moon passes Castor, Pollux and Venus.

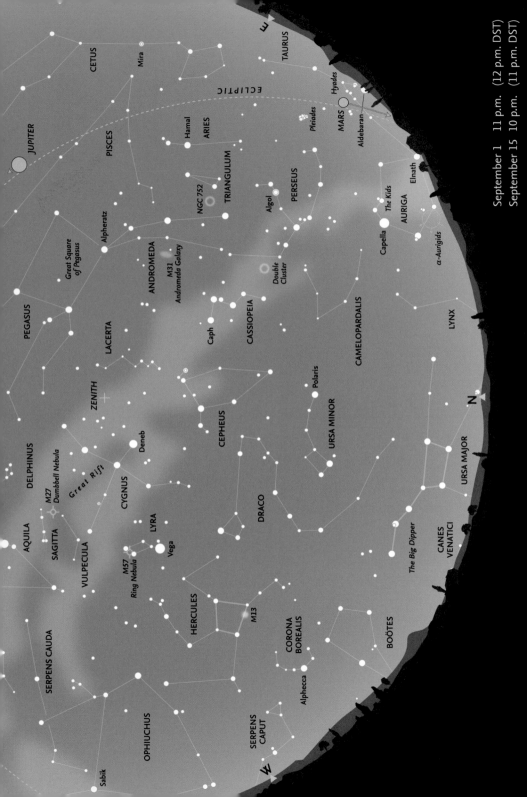

September 1 11 p.m. (12 p.m. DST)
September 15 10 p.m. (11 p.m. DST)

September – Looking North

The (northern) autumnal equinox occurs on September 23, when the Sun moves south of the equator in Virgo.

Ursa Major is now low in the north, and to the northwest **Arcturus** and much of **Boötes** have sunk below the horizon. In the northeast, **Auriga** is beginning to climb higher in the sky. Later in the month, **Taurus**, with orange **Aldebaran** (αTauri), and even **Gemini**, with **Castor** and **Pollux**, become visible in the east and northeast. Due east, **Andromeda** is now easily visible, with the small constellations of **Triangulum** and **Aries** (the latter a zodiacal constellation) directly below it. Practically the whole of the northern Milky Way is visible, arching across the sky, both in the north and in the south. It is not particularly clear in Auriga, or even **Perseus**, but in **Cassiopeia** and on toward **Cygnus** the clouds of stars become easier to see. The **Double Cluster** in Perseus is well placed for observation. **Cepheus** is "upside-down" near the zenith, and the head of **Draco** and **Hercules** beyond it are well placed for observation.

Meteors

After the major Perseid shower in August, there is very little shower activity in September. One minor, but very extended, shower, known as the **α-Aurigids**, tends to have two peaks of activity. The principal peak occurs on September 1. In 2022, the Moon is a waxing crescent (First Quarter is on September 3), so conditions are not very favorable. At maximum, however, the hourly rate hardly reaches 10 meteors per hour, although the meteors are bright and relatively easy to photograph. Activity from this shower may even extend into October. The **Southern Taurid** shower begins this month (on September 10) and, although rates are low, often produces very bright fireballs. This is a very long shower, lasting until about November 20. As a slight compensation for the lack of shower activity, however, in September the number of sporadic meteors reaches its highest rate at any time during the year.

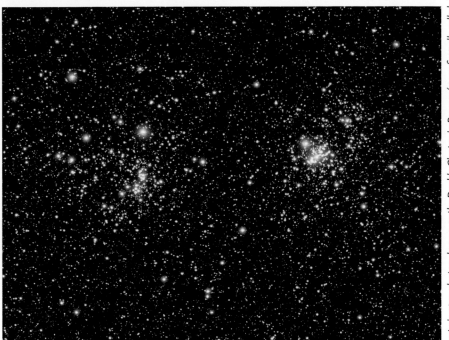

The twin open clusters, known as the Double Cluster, in Perseus (more formally called h and χ Persei) are close to the main portion of the Milky Way.

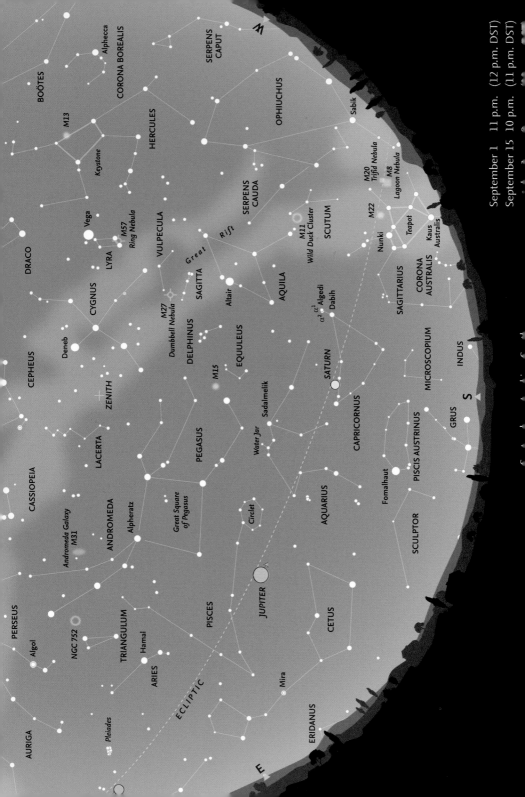

September 1 11 p.m. (12 p.m. DST)
September 15 10 p.m. (11 p.m. DST)

September – Looking South

The "Summer Triangle" is now high in the southwest, with the Great Square of **Pegasus** high in the southeast. Below Pegasus are the two zodiacal constellations of **Capricornus** and **Aquarius**. In what is otherwise an unremarkable constellation, **Algedi** (α Capricorni) is actually a visual binary, with the two stars (α¹ Cap and α² Cap) readily seen with the naked eye. **Dabih** (β Capricorni), just to the south, is also a double star, and the components are relatively easy to separate with binoculars. In Aquarius, just to the east of **Sadalmelik** (α Aquarii) there is a small asterism consisting of four stars, resembling a tiny letter "Y," known as the "Water Jar." Below Aquarius is a sparsely populated area of the sky with just one bright star in the constellation of **Piscis Austrinus**. In classical illustrations, water is shown flowing from the "Water Jar" toward bright **Fomalhaut** (α Piscis Austrini).

Another zodiacal constellation, **Pisces**, is now clearly visible to the east of Aquarius. Although faint, there is a distinctive asterism of stars, known as the "Circlet," south of the Great Square and another line of faint stars to the east of Pegasus. Still farther down toward the horizon

The zodiacal constellation of Capricornus, photographed in 2009. The brilliant object is the planet Jupiter, which will lie farther east in 2022.

is the constellation of **Cetus**, with the famous variable star **Mira** (o Ceti) at its center. When Mira is at maximum brightness (around mag. 3.5) it is clearly visible to the naked eye, but it disappears as it fades toward minimum (about mag. 9.5 or less). There is a finder chart for Mira on page 97.

The Moon's phases for September

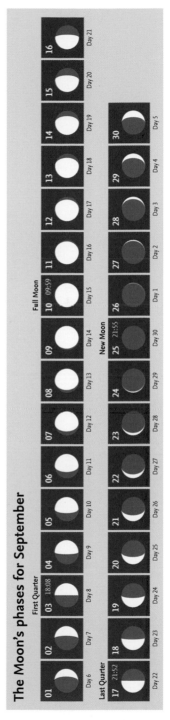

September – Moon and Planets

The Moon

The First Quarter Moon is 2.5° north of **Antares** in **Scorpius** on September 3. On September 8, the Moon passes 3.9° south of **Saturn**. On September 11, one day past Full, the Moon is 1.8° south of **Jupiter**. Just before Last Quarter, the Moon is 3.6° north of **Mars** on September 17. On September 20, the Moon is 1.9° south of **Pollux** in **Gemini**. The Moon is close to **Venus** on September 25, low in the morning twilight. On September 30, the Moon again passes (2.3° north) of **Antares** as it did at the beginning of the month.

The planets

Mercury is close to the Sun, and comes to inferior conjunction on September 23. Venus is also close to the Sun, but may be glimpsed in morning twilight later in the month. **Mars** is moving eastwards in **Taurus**, brightening from mag. -0.1 to mag. -0.6 over the month. **Jupiter** (mag. -2.9) comes to opposition on September 26. **Saturn** remains in **Capricornus** at mag. 0.4 to 0.5. **Uranus** remains in **Aries** at mag. 5.8, and **Neptune** is in **Aquarius** at mag. 7.8, coming to opposition on September 16. On September 7, minor planet **(3) Juno** is at opposition at mag. 7.9 (see chart on page 27).

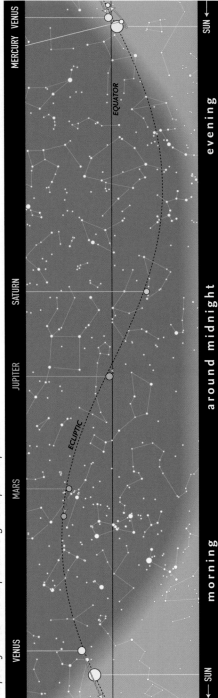

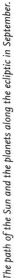

The path of the Sun and the planets along the ecliptic in September.

Evening 10 p.m. (DST)

September 10–11 • The waning gibbous Moon passes below Jupiter in the east-southeast. Diphda (β Cet) is closer to the horizon.

Evening 7:30 p.m. (DST)

September 30 • The Moon is close to Antares in the southwest. Sabik,

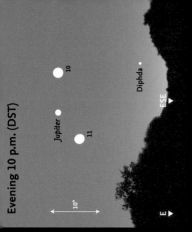

...south.

Evening 8 p.m. (DST)

September 2–3 • The First Quarter Moon passes Acrab (β Sco), Dschubba (δ Sco) and Antares, low in the south-southwest. The "Cat's Eyes" are farther

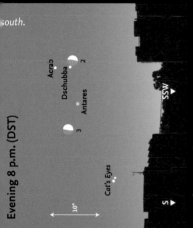

Early morning 3 a.m. (DST)

September 16–17 • The Moon passes the Pleiades, Aldebaran and

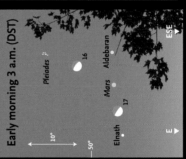

Early morning 4 a.m. (DST)

September 20 • Early in the morning, the Moon aligns with

Calendar for September

01		α-Aurigid meteor shower maximum
03	15:29	Antares 2.5°S of Moon
03	18:08	First Quarter
05	01:00 *	Venus is 0.8°N of Regulus
07	16:49	Minor planet (3) Juno at opposition (mag. 7.9)
07	18:19	Moon at perigee = 364,492 km
08	10:31	Saturn 3.9°N of Moon
09	01:00 *	Mars 4.3°N of Aldebaran
10–Nov.20		Southern Taurid meteor shower
10	09:59	Full Moon
10	18:54	Neptune 3.0°N of Moon
11	15:17	Jupiter 1.8°N of Moon
14	22:59	Uranus 0.8°S of Moon
16	18:19	Aldebaran 7.8°S of Moon
16	22:21	Neptune at opposition (mag. 7.8)
17	01:43	Mars 3.6°S of Moon
17	21:52	Last Quarter
19	14:43	Moon at apogee = 404,556 km
20	08:17	Pollux 1.9°N of Moon
23	01:04	Northern autumnal equinox
23	04:51	Regulus 4.8°S of Moon
23	06:50	Mercury at inferior conjunction
25	05:08	Venus 2.8°S of Moon
25	08:14	Mercury 6.7°S of Moon
25	21:55	New Moon
26	19:33	Jupiter at opposition (mag. -2.9)
27	09:57	Spica 4.2°S of Moon
30	20:53	Antares 2.3°S of Moon

These objects are close together for an extended

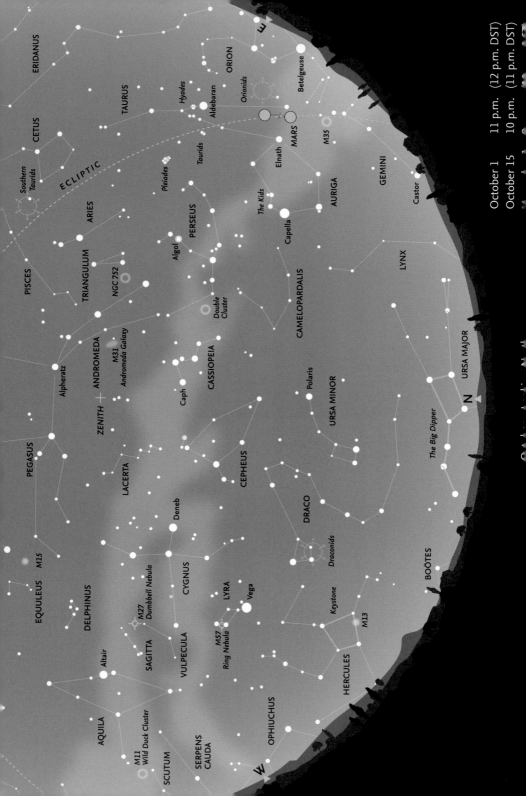

October 1 11 p.m. (12 p.m. DST)
October 15 10 p.m. (11 p.m. DST)

October – Looking North

Ursa Major is grazing the horizon in the north, while high overhead are the constellations of **Cepheus**, **Cassiopeia** and **Perseus**, with the Milky Way between Cepheus and Cassiopeia below the zenith. **Auriga** is now clearly visible in the east, as is **Taurus** with the **Pleiades**, **Hyades** and orange **Aldebaran**. Also in the east, **Orion** and **Gemini** are starting to rise clear of the horizon.

The constellations of **Boötes** and **Corona Borealis** are now lost to view in the northwest, and **Hercules** is also descending toward the western horizon. The three stars of the "Summer Triangle" are still clearly visible, although **Aquila** and **Altair** are beginning to approach the horizon in the west. Toward the end of the month (October 30) Summer Time ends in Europe. In North America, the end of DST comes next month, in November.

Meteors

The **Orionids** are the major, fairly reliable meteor shower active in October. Like the May **η-Aquariid** shower, the Orionids are associated with Comet 1P/Halley. During this second pass through the stream of particles from the comet, slightly fewer meteors are seen than in May, but conditions are more favorable for northern observers. In both showers the meteors are very fast, and many leave persistent trains. Although the Orionid maximum is quoted as October 21, in fact there is a very broad maximum, lasting about a week roughly centered on that date, with hourly rates around 25. Occasionally, rates are higher (50–70 per hour). In 2022, the Moon is a waning crescent, so conditions are reasonably favorable.

The faint shower of the **Southern Taurids** (often with bright fireballs) peaks on October 10. The Southern Taurid maximum occurs one day after Full Moon, so conditions are particularly unfavorable, compared

The constellation of Perseus is not only the location of the radiant of the Perseid meteor shower in August, but is also well known for the pair of open clusters, called the Double Cluster (near the top edge of the image), close to the border with Cassiopeia, and also for Algol (β Persei), the famous variable star (just below the center of the photograph).

with the Orionids. Toward the end of the month (around October 20), another shower (the Northern Taurids) begins to show activity, which peaks early in November. The parent comet for both Taurid showers is Comet 2P/Encke. The meteors in both Taurid streams are relatively slow and bright.

A minor shower, the **Draconids**, begins on October 6 and peaks on October 8–9.

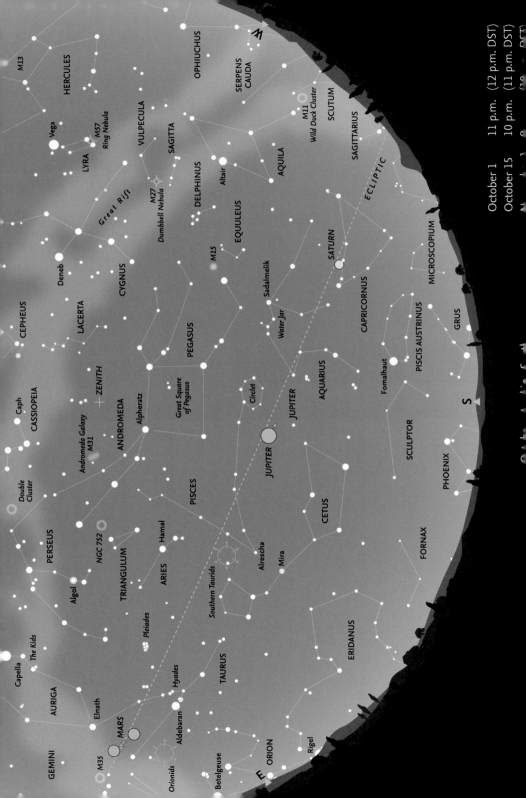

M13

HERCULES

OPHIUCHUS

SERPENS
CAUDA

M11
Wild Duck Cluster

SCUTUM

Vega

LYRA

M57
Ring Nebula

VULPECULA

SAGITTA

SAGITTARIUS

Great Rift

M27
Dumbbell Nebula

DELPHINUS

Altair

AQUILA

ECLIPTIC

Deneb

CYGNUS

M15

EQUULEUS

SATURN

CEPHEUS

LACERTA

PEGASUS

Sadalmelik

CAPRICORNUS

MICROSCOPIUM

Caph
CASSIOPEIA

ZENITH

Water Jar

GRUS

ANDROMEDA

Great Square
of Pegasus

AQUARIUS

PISCIS AUSTRINUS

Andromeda Galaxy
M31

Alpheratz

Circlet

JUPITER

Fomalhaut

Double
Cluster

PISCES

JUPITER

SCULPTOR

S

PERSEUS

NGC 752

Hamal

Alrescha

CETUS

PHOENIX

Algol

TRIANGULUM

ARIES

Southern Taurids

Mira

FORNAX

Pleiades

ERIDANUS

Capella

The Kids

TAURUS

AURIGA

Elnath

Hyades

Aldebaran

GEMINI

MARS

Betelgeuse

E ORION

M35

Orionids

Rigel

October 1 11 p.m. (12 p.m. DST)
October 15 10 p.m. (11 p.m. DST)

October – Looking South

The Great Square of **Pegasus** dominates the southern sky, framed by the two chains of stars that form the constellation of **Pisces**, together with **Alrescha** (α Piscium) at the point where the two lines of stars join. Also clearly visible is the constellation of **Cetus**, below Pegasus and Pisces. Although **Capricornus** is now lower, **Aquarius** to its east is well placed in the south, with solitary **Fomalhaut** and the constellation of **Piscis Austrinus** beneath it. The inconspicuous constellation of **Sculptor** appears in the south, as well as parts of **Grus**, **Phoenix** and, farther east, the northernmost stars of **Eridanus**.

The main band of the Milky Way and the Great Rift runs down from **Cygnus**, through **Vulpecula**, **Sagitta** and **Aquila** toward the western horizon. **Delphinus** and the tiny, unremarkable constellation of **Equuleus** lie between the band of the Milky Way and Pegasus. **Andromeda** is clearly visible high in the sky to the southeast, with the small constellation of **Triangulum** and the zodiacal constellation of **Aries** below it. **Perseus** is high in the east, and by now the **Pleiades** and **Taurus** are well clear of the horizon. Later in the night, and later in the month, **Orion** rises in the east, a sign that the autumn season has arrived and of the steady approach of winter.

The Moon's phases for October

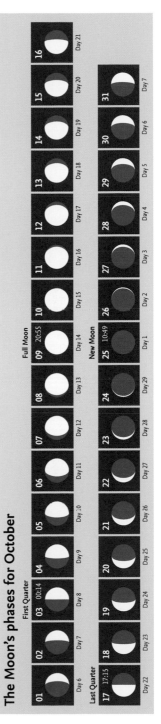

The constellation of Aquarius is one of the constellations that is visible in late summer and early autumn. The four stars forming the "Y"-shape of the "Water Jar" may be seen to the east of Sadalmelik (α Aquarii), the brightest star (top center).

October – Moon and Planets

The Moon

On October 8, one day before Full Moon, it is 2.1° south of **Jupiter** in **Pisces**. It passes 0.9° north of **Uranus** (mag. 5.7) in **Aries** on October 12. Waning gibbous, it passes **Aldebaran** on October 14, and is 3.6° north of **Mars** the next day. At Last Quarter, on October 17, it is 1.8° south of **Pollux**. As a waning crescent, on October 20 it is 4.9° north of **Regulus**, between it and **Algieba**. It is 4.2° north of **Spica** on October 24, and at New Moon, the next day, there is a partial solar eclipse (see page 20). The waxing crescent is 2.3° north of **Antares** on October 28.

The planets

Mercury is at greatest elongation west at mag. -0.6 on October 8, low in the morning sky. **Venus** is close to the Sun, and comes to superior conjunction on October 22. It is occulted by the Moon on October 25, but the event occurs in daylight. **Mars**, in **Taurus**, brightens from mag. -0.6 to mag. -1.2 over the month. It begins retrograde motion on October 31. **Jupiter**, after opposition in September, is still retrograding in **Pisces** at mag. -2.9 to -2.8. **Saturn** is retrograding slowly in **Capricornus** and resumes direct motion on October 23. **Uranus** (mag. 5.7) is in **Aries**, and **Neptune** (mag. 7.8) in **Aquarius**.

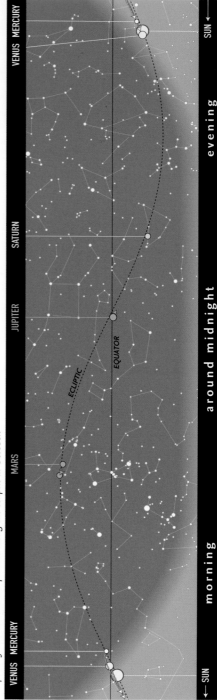

The path of the Sun and the planets along the ecliptic in October.

Calendar for October

02–Nov.07	Orionid meteor shower	
03	00:14	First Quarter
04	16:34	Moon at perigee = 369,325 km
05	15:51	Saturn 4.1°N of Moon
06–10		Draconid meteor shower
08–09		Draconid meteor shower maximum
08	02:33	Neptune 3.1°N of Moon
08	18:12	Jupiter 2.1°N of Moon
08	21:14	Mercury at greatest elongation (18.0°W, mag. –0.6)
09	20:55	Full Moon
10–11		Southern Taurid meteor shower maximum
12	06:46	Uranus 0.9°S of Moon
14	02:56	Aldebaran 8.0°S of Moon
15	04:31	Mars 3.6°S of Moon
17	10:20	Moon at apogee = 404,328 km
17	16:19	Pollux 1.8°N of Moon
17	17:15	Last Quarter
20–Dec.10		Northern Taurid meteor shower
20	13:17	Regulus 4.9°S of Moon
21–22		Orionid meteor shower maximum
22	21:17	Venus at superior conjunction
24	15:44	Mercury 0.4°S of Moon
24	18:14	Spica 4.2°S of Moon
25	10:49	New Moon
25	11:00	Partial solar eclipse
25	12:05	Venus occultation
28	03:21	Antares 2.3°S of Moon
29	14:36	Moon at perigee = 368,291 km
30		European Daylight Saving Time ends (UK Summer Time)

Evening 7 p.m. (DST)

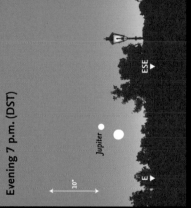

October 8 • The nearly Full Moon with Jupiter, low in the east-southeast.

After midnight 1 a.m. (DST)

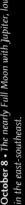

October 16–18 • Around Last Quarter, the Moon passes Alhena and Castor & Pollux. Procyon is near the eastern horizon.

Evening 11 p.m. (DST)

October 12–14 • The Moon passes the Pleiades, Aldebaran, Mars, and Elnath. Capella is farther northeast and Bellatrix (γ Ori) is close to the horizon, almost due east.

Early morning 5:30 a.m. (DST)

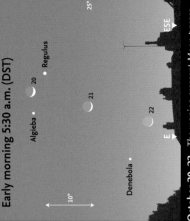
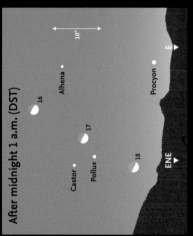

October 20–22 • The waning crescent Moon passes between Regulus and Algieba, in the eastern sky. Denebola is lower and farther northeast.

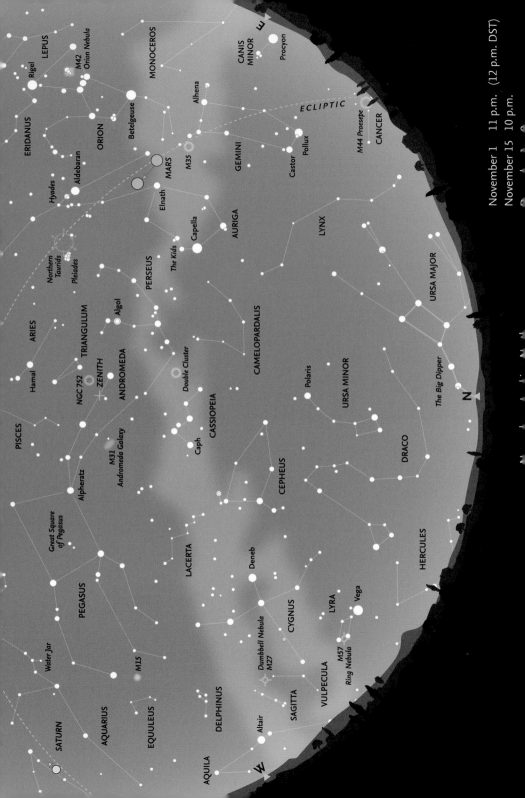

November 1 11 p.m. (12 p.m. DST)
November 15 10 p.m.

November – Looking North

Most of **Aquila** has now disappeared below the horizon, but two of the stars of the "Summer Triangle," **Vega** in **Lyra** and **Deneb** in **Cygnus**, are still clearly visible in the west. The head of **Draco** is now low in the northwest and only a small portion of **Hercules** remains above the horizon. The southernmost stars of **Ursa Major** are now coming into view. The Milky Way arches overhead, with the denser star clouds in the west and the less heavily populated region through **Auriga** and **Monoceros** in the east. High overhead, **Cassiopeia** is near the zenith and **Cepheus** has swung round to the northwest, while Auriga is now high in the northeast. **Gemini**, with **Castor** and **Pollux**, is well clear of the eastern horizon, and even **Procyon** (α Canis Minoris) is just climbing into view almost due east.

Meteors

The **Northern Taurid** shower, which began in mid-October, reaches maximum – although with just a low rate of about five meteors per hour – on November 12. Full Moon is on November 8, so conditions are not favorable. The shower gradually trails off, ending around December 10. There is an apparent 7-year periodicity in fireball activity, but 2022 is unlikely to be a peak year. Far more striking, however, are the **Leonids**, which have a relatively short period of activity (November 6–30), with maximum on November 17–18. This shower is associated with Comet 55P/Tempel-Tuttle and has shown extraordinary activity on various occasions with many thousands of meteors per hour. High rates were seen in 1999, 2001 and 2002 (reaching about 3,000 meteors per hour) but have fallen dramatically since then. The rate in 2022 is likely to be about 15 per hour. These meteors are the fastest shower meteors recorded (about 70 km per second) and often leave persistent trains. The shower is very rich in faint meteors. In 2022, maximum is just after Last Quarter, so conditions are not particularly favorable.

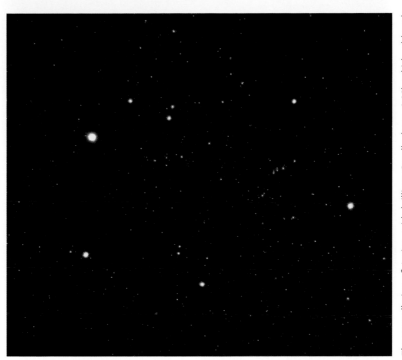

The constellation of Auriga, with brilliant Capella (mag. 0.08), which, although appearing as a single star, is actually a quadruple system, consisting of a pair of yellow giant stars, gravitationally bound to a more distant pair of red dwarfs.

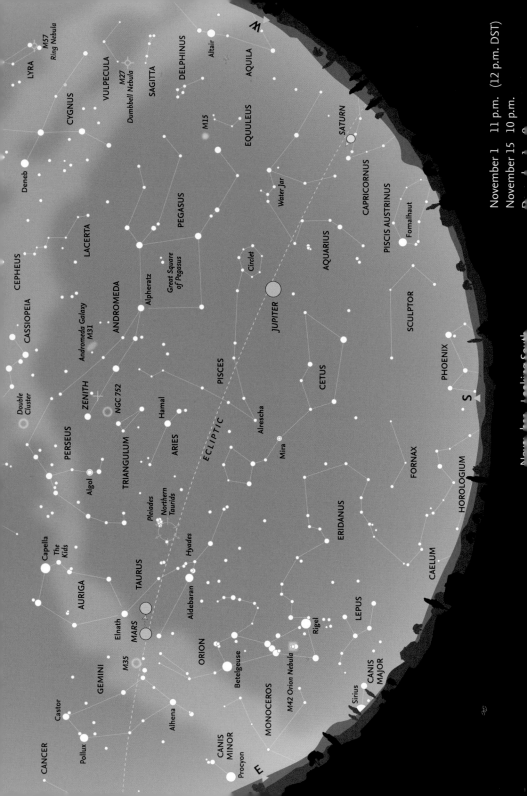

November 1 11 p.m. (12 p.m. DST)
November 15 10 p.m.

November – Looking South

Orion has now risen above the eastern horizon, and much of the long, straggling constellation of **Eridanus** (which begins near **Rigel**) is visible to the west of Orion as is the small constellation of **Fornax**. Parts of **Horologium** and **Phoenix** are peeping above the southern horizon. Higher in the sky, **Taurus**, with the **Pleiades** cluster, and orange **Aldebaran** are now easy to observe. To their west, both **Pisces** and **Cetus** are close to the meridian. The famous long-period variable star, **Mira** (o Ceti), with a typical range of magnitude 3.4 to 9.8, is favorably placed for observation. In the southwest, **Capricornus** has slipped below the horizon, but **Aquarius** remains visible. Even farther west, **Altair** may be seen early in the night, but most of **Aquila** has already disappeared from view. **Delphinus**, together with **Sagitta** and **Vulpecula** in the Milky Way, will soon vanish for another year. Both **Pegasus** and **Andromeda** are easy to see, and one of the lines of stars that make up Andromeda finishes close to the zenith, which is also close to one of the outlying stars of **Perseus**, high in the east.

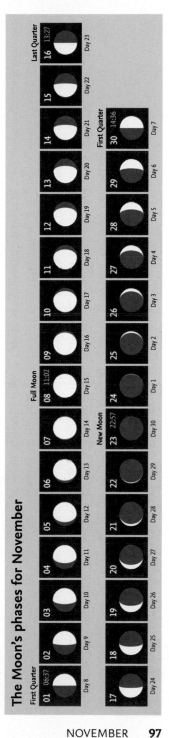

Finder and comparison charts for Mira (o Ceti). The chart on the left shows all stars brighter than magnitude 6.5. The chart on the right shows stars down to magnitude 10.0. The comparison star magnitudes are shown without the decimal point.

The Moon's phases for November

November – Moon and Planets

The Moon

Just after First Quarter on November 1, the Moon is 4.2° south of *Saturn.* On November 4 it is 2.4° south of *Jupiter* in Pisces. There is a total lunar eclipse at Full Moon on November 8 (see page 20). The Moon is 8.0° north of *Aldebaran* on November 10 and is 2.5° north of *Mars* in *Taurus* the next day. The Moon is 1.7° south of *Pollux* on November 14. Just after Last Quarter, on November 16, the Moon is 5.0° north of *Regulus.* On November 21 it is 4.2° north of *Spica* in *Virgo.* On November 29, it again passes 4.2° south of Saturn, as it did on November 1.

The planets

Mercury comes to superior conjunction on November 8. *Venus,* although bright (mag. -4.0 to -3.9) is lost in twilight, close to the Sun. *Mars,* which began retrograde motion on October 31, is in *Taurus,* brightening from mag. -1.2 to -1.8 over the month. *Jupiter* (mag. -2.8 to -2.6), initially retrograding in *Pisces,* resumes direct motion on November 26. *Saturn* (mag. 0.7 to 0.8) is moving slowly eastwards in *Capricornus. Uranus,* in *Aries* at mag. 5.6 is at opposition on November 9. *Neptune* is in *Aquarius* at mag. 7.8 to 7.9.

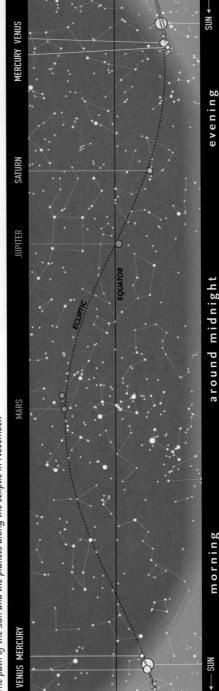

The path of the Sun and the planets along the ecliptic in November.

Calendar for November

01	06:37	First Quarter
01	21:08	Saturn 4.2°N of Moon
04	08:20	Neptune 3.2°N of Moon
04	20:24	Jupiter 2.4°N of Moon
06		North American Daylight Saving Time ends
06–30		Leonid meteor shower
08	10:58	Total lunar eclipse
08	11:02	Full Moon
08	13:11	Uranus 0.8°S of Moon
08	16:43	Mercury at superior conjunction
09	08:26	Uranus at opposition (mag. 5.6)
10	11:22	Aldebaran 8.0°S of Moon
11	13:46	Mars 2.5°S of Moon
12–13		Northern Taurid meteor shower maximum
14	00:20	Pollux 1.7°N of Moon
14	06:40	Moon at apogee = 404,921 km
16	13:27	Last Quarter
16	21:53	Regulus 5.0°S of Moon
17–18		Leonid meteor shower maximum
21	04:11	Spica 4.2°S of Moon
23	22:57	New Moon
24	12:18	Antares 2.3°S of Moon
24	14:02	Venus 2.3°N of Moon
24	15:03	Mercury 0.9°N of Moon
26	01 31	Moon at perigee = 362,826 km
29	04:40	Saturn 4.2°N of Moon
30	14:36	First Quarter

Evening 9 p.m. (DST)

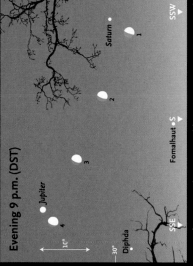

November 1–4 • *The waxing gibbous Moon passes Saturn and is close to Jupiter on November 4. Fomalhaut is closer to the horizon and almost due south.*

Evening 9 p.m.

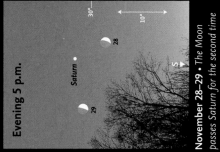

November 10–11 • *The Moon passes Mars and Elnath, surrounded by Alhena, Betelgeuse, Bellatrix (γ Ori) and Aldebaran.*

Evening 11 p.m.

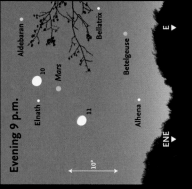

November 12–13 • *The Moon passes the twin stars, Castor and Pollux.*

Morning 6 a.m.

November 20–21 • *The waning crescent Moon passes Spica, in the southeast.*

Evening 5 p.m.

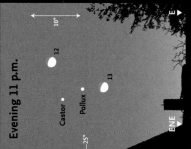

November 28–29 • *The Moon passes Saturn for the second time this month.*

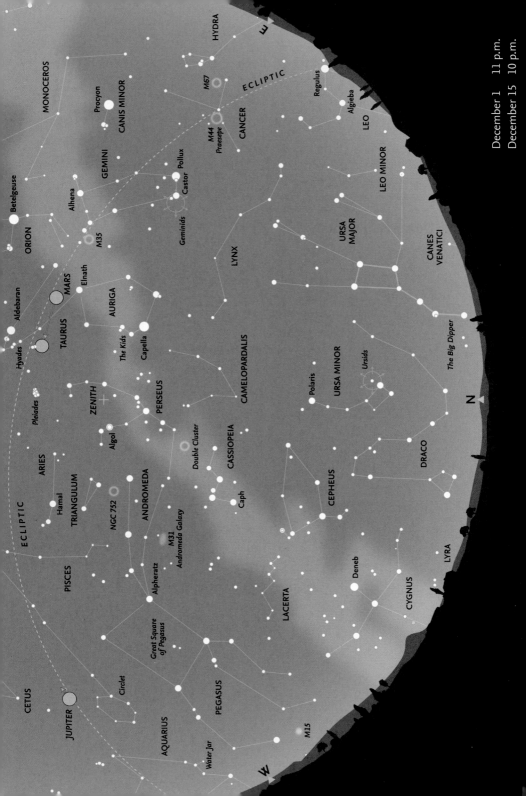

December 1 11 p.m.
December 15 10 p.m.

December—Looking North

Ursa Major has now swung around and is starting to "climb" in the east. The fainter stars in the southern part of the constellation are now fully in view. The other bear, *Ursa Minor*, "hangs" below *Polaris* in the north. Directly above it is the faint constellation of *Camelopardalis*, with the other inconspicuous circumpolar constellation, *Lynx*, to its east. *Vega* (α Lyrae) is now below the horizon in the northwest, but *Deneb* (α Cygni) and most of *Cygnus* remain visible farther west. In the east, *Regulus* (α Leonis) and the constellation of *Leo* are beginning to rise above the horizon. *Cancer* stands high in the east, with *Gemini* even higher in the sky. *Perseus* is at the zenith, with *Auriga* and *Capella* between it and Gemini. Because it is so high in the sky, now is a good time to examine the star clouds of the fainter portion of the Milky Way, between *Cassiopeia* in the west to Gemini and *Orion* in the east.

Meteors

There is one significant meteor shower in December (the last major shower of the year). This is the *Geminid* shower, which is visible over the period December 4–20 and comes to maximum on December 14–15, when the Moon is waning gibbous so conditions are not wonderful. It is one of the most active showers of the year, and in some years is the strongest, with a peak rate of around 100 meteors per hour. It is the one major shower that shows good activity before midnight. The meteors have been found to have a much higher density than other meteors (which are derived from cometary material). It was eventually established that the Geminids and the asteroid Phaeton had similar orbits. So the Geminids are assumed to consist of denser, rocky material. They are slower than most other meteors and often appear to last longer. The brightest often break up into numerous luminous fragments that follow similar paths across the sky. There is a second shower: the *Ursids*, active December 17–26, peaking on December 22–23,

with a rate at maximum of 5–10, occasionally rising to 25 per hour. Maximum in 2022 occurs at New Moon, so conditions are extremely favorable. The parent body is Comet 8P/Tuttle.

The constellation of Andromeda largely consists of a line of bright stars running northeast from α Andromedae, Alpheratz (bottom right), which is one of the stars forming the Great Square of Pegasus. The small constellation of Triangulum appears on the left-hand (eastern) side, below Andromeda.

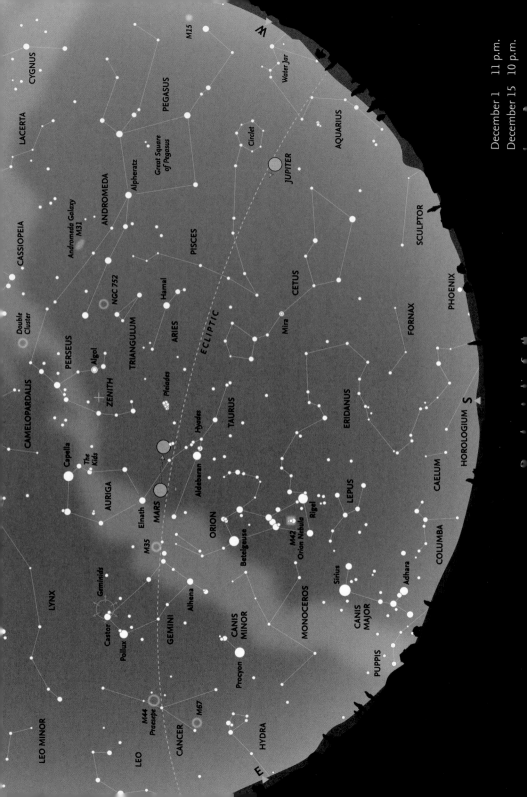

December – Looking South

The fine open cluster of the *Pleiades* is due south around 10 p.m., high in the sky, with the *Hyades* cluster, *Aldebaran* and the rest of *Taurus* clearly visible to the east. *Auriga* (with *Capella*) and *Gemini* (with *Castor* and *Pollux*) are both well placed for observation. *Orion* has made a welcome return to the winter sky, and both *Canis Minor* (with *Procyon*) and *Canis Major* (with *Sirius*, the brightest star in the sky) are now well above the horizon. The small, poorly known constellation of *Lepus* lies to the south of Orion, with *Columba* closer to the horizon. The northernmost portion of *Eridanus* is clearly visible in the south. In the west, *Aquarius* has now disappeared, and *Cetus* is becoming lower, but *Pisces* is still easily seen, as are the constellations of *Aries*, *Triangulum* and *Andromeda* above it. The Great Square of *Pegasus* is starting to plunge down toward the western horizon and, because of its orientation on the sky, appears more like a large diamond, standing on one point, than a square.

The Moon's phases for December

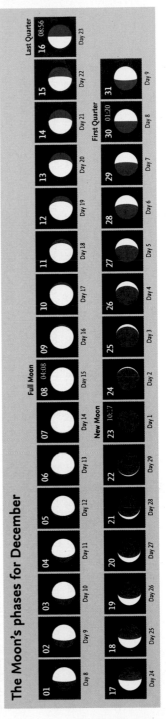

The constellation of Taurus contains two contrasting open clusters: the compact Pleiades, with its striking blue-white stars, and the more scattered, "V"-shaped Hyades, which are much closer to us. Orange Aldebaran (α Tauri) is not related to the Hyades, but lies between it and the Earth.

December – Moon and Planets

The Moon

On December 2, the Moon (waxing gibbous) is 2.5° south of *Jupiter* in *Pisces*. On December 8, a few minutes after Full Moon, it occults *Mars* (at opposition) in *Taurus*. The waning gibbous Moon passes 1.8° south of *Pollux* on December 11. On December 14 it passes 4.8° north of *Regulus*, between it and *Algieba*. On December 18 the Moon is 4.1° North of *Spica* in *Virgo*. On December 21, shortly before New Moon, it is 2.3° north of *Antares*. On December 24 it passes just south of both *Mercury* and *Venus*, but is so low it is probably lost in twilight. On December 26 it passes 4.0° south of *Saturn* in *Capricornus* and, on December 29, again 2.3° south of *Jupiter* as it was early in the month.

The planets

Mercury reaches greatest elongation east in the evening sky (20.1°, mag. -0.6) on December 21. *Venus* (mag. -3.9) becomes visible in the evening sky later in the month. *Mars* is in *Taurus* and comes to opposition on December 8 at mag. -1.9, when it is also occulted by the Full Moon. Although conditions will be difficult, the occultation should be visible from Western Europe and practically the whole of North America. *Jupiter* (mag. -2.6 to -2.4) is moving eastwards (direct motion) in *Pisces*. *Saturn* is in *Capricornus* at mag. 0.8. *Uranus* is still retrograding in *Aries*, and fades very slightly to mag. 5.7 at the end of the year. *Neptune* remains in *Aquarius* at mag. 7.6, but resumes direct motion on December 26.

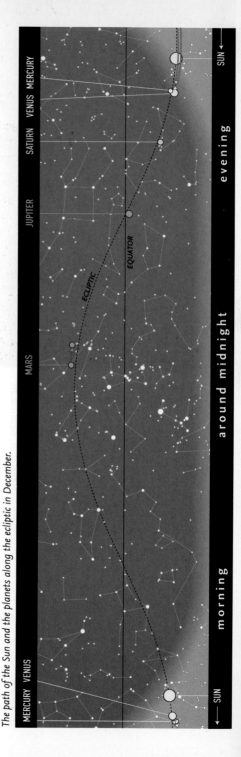

The path of the Sun and the planets along the ecliptic in December.

Calendar for December

01	13:22	Neptune 3.2°N of Moon
02	00:57	Jupiter 2.5°N of Moon
04–20		Geminid meteor shower
05	17:59	Uranus 0.7°S of Moon
07	18:43	Aldebaran 8.0°S of Moon
08	04:08	Full Moon
08	04:25	Occultation of Mars
08	05:42	Mars at opposition (mag. -1.9)
11	07:44	Pollux 1.8°N of Moon
12	00:28	Moon at apogee = 405,869 km
14–15		Geminid meteor shower maximum
14	05:38	Regulus 4.8°S of Moon
16	08:56	Last Quarter
17–26		Ursid meteor shower
18	14:13	Spica 4.1°S of Moon
21	15:31	Mercury at greatest elongation (20.1°E, mag. -0.6)
21	21:48	Northern winter solstice
21	23:15	Antares 2.3°S of Moon
22	04:00 *	Mars 8.2°N of Aldebaran
22–23		Ursid meteor shower maximum
23	10:17	New Moon
24	08:27	Moon at perigee = 358,270 km
24	11:28	Venus 3.8°N of Moon
24	18:30	Mercury 3.8°N of Moon
26	16:11	Saturn 4.0°N of Moon
28	20:03	Neptune 3.0°N of Moon
29	09:00 *	Mercury 1.4°N of Venus
29	10:34	Jupiter 2.3°N of Moon
30	01:20	First Quarter

** These objects are close together for an extended period around this time.*

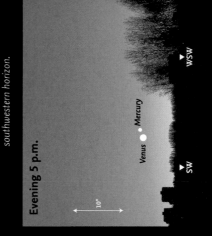

Evening 5 p.m.

December 24 • *Venus, Mercury and the narrow crescent Moon, near the southwestern horizon.*

After midnight 0:30 a.m.

December 14 • *The Moon is between Regulus and Algieba, high in the east.*

Morning 5 a.m.

December 7–8 • *The Moon passes Aldebaran, Mars and Einath.*

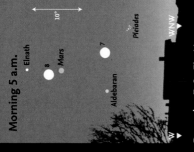

Evening 5 p.m.

December 29 • *Venus and Mercury are close together low in the southwest.*

Evening 6 p.m.

December 28–29 • *The Moon is almost at First Quarter when it passes below Jupiter. Diphda (β Cet) is closer to the horizon and due south.*

Dark Sky Sites

International Dark Sky Association Sites

The *International Dark-Sky Association* (IDA) recognizes various categories of sites that offer areas where the sky is dark at night, free from light pollution and particularly suitable for astonomical observing. There are numerous sites in North America, shown on the map and listed here.

Details of IDA are at: https://www.darksky.org/. Information on the various categories and individual sites are at: https://www.darksky.org/our-work/conservation/idsp/.

Many of these sites have major observatories or other facilities available for public observing (often at specific dates or times).

Parks

1. *Antelope Island State Park* (UT)
2. *Anza-Borrego Desert State Park* (CA)
3. *Arches National Park* (UT)
4. *Big Bend National Park* (TX)
5. *Big Bend Ranch State Park* (TX)
6. *Big Cypress National Preserve* (FL)
7. *Black Canyon of the Gunnison National Park* (CO)
8. *Bryce Canyon National Park* (UT)
9. *Buffalo National River* (AR)
10. *Canyonlands National Park* (UT)
11. *Capitol Reef National Park* (UT)
12. *Capulin Volcano National Monument* (NM)
13. *Cedar Breaks National Monument* (UT)
14. *Chaco Culture National Historical* Park (NM)
15. *Cherry Springs State Park* (PA)
16. *Clayton Lake State Park* (NM)
17. *Copper Breaks State Park* (TX)
18. *Craters Of The Moon National Monument* (ID)
19. *Dead Horse Point State Park* (UT)
20. *Death Valley National Park* (CA)
21. *Dinosaur National Monument* (CO)
22. *Dr. T.K. Lawless County Park* (MI)
23. *El Morro National Monument* (NM)
24. *Enchanted Rock State Natural Area* (TX)
25. *Flagstaff Area National Monuments* (AZ)
26. *Fort Union National Monument* (NM)
27. *Geauga Observatory Park* (OH)
28. *Goblin Valley State Park* (UT)
29. *Grand Canyon National Park* (AZ)
30. *Grand Canyon-Parashant National Monument* (AZ)
31. *Great Basin National Park* (NV)
32. *Great Sand Dunes National Park and Preserve* (CO)
33. *Headlands* (MI)
34. *Hovenweep National Monument* (UT)
35. *Jackson Lake State Park* (CO)
36. *James River State Park* (VA)
37. *Joshua Tree National Park* (CA)
38. *Kartchner Caverns State Park* (AZ)
39. *Kissimmee Prairie Preserve State Park* (FL)
40. *Mayland Earth to Sky Park & Bare Dark Sky Observatory* (NC)
41. *Middle Fork River Forest Preserve* (IL)
42. *Natural Bridges National Monument* (UT)
43. *Newport State Park* (WI)
44. *Obed Wild and Scenic River* (TN)
45. *Oracle State Park* (AZ)
46. *Petrified Forest National Park* (AZ)
47. *Pickett CCC Memorial State Park & Pogue Creek Canyon State Natural Area* (TN)
48. *Rappahannock County Park* (VA)
49. *Salinas Pueblo Missions National Monument* (NM)
50. *South Llano River State Park* (TX)
51. *Staunton River State Park* (VA)
52. *Steinaker State Park* (UT)
53. *Stephen C. Foster State Park* (GA)
54. *Tonto National Monument* (AZ)
55. *Tumacácori National Historical Park* (AZ)
56. *UBarU Camp and Retreat Center* (TX)
57. *Waterton-Glacier International Peace Park* (Canada/MT)
58. *Weber County North Fork Park* (UT)

Reserves

59. *Central Idaho* (ID)
60. *Mont-Mégantic* (Québec)

Sanctuaries

61. *Boundary Craters Canoe Area Wilderness* (MN)
62. *Cosmic Campground* (NM)
63. *Devils River State Natural Area – Del Norte Unit* (TX)
64. *Katahdin Woods and Waters National Monument* (ME)
65. *Massacre Rim* (NV)
66. *Medicine Rocks State Park* (MT)
67. *Rainbow Bridge National Monument* (UT)

RASC Recognized Dark-Sky Sites

Canadian Dark-Sky Sites

The Royal Astronomical Societ of Canada (RASC) has developed formal guidelines and requirements for three types of light-restricted protected areas: Dark-Sky Preserves, Urban Star Parks and Nocturnal Preserves. The focus of the Canadian Program is primarily to protect the nocturnal environment; therefore, the outdoor lighting requirements are the most stringent, but also the most effective. Canadian Parks and other areas that meet these guidelines and successfully apply for one of these designations are officially recognized. Many parks across Canada have been designated in recent years – see the list below and the RASC website: https://rasc.ca/lpa/dark-sky-sites.

Dark-Sky Preserves

1 *Torrance Barrens Dark-Sky Preserve* (ON)
2 *McDonald Park Dark-Sky Park* (BC)
3 *Cypress Hills Inter-Provincial Park Dark-Sky Preserve* (SK/AB)
4 *Point Pelee National Park* (ON)
5 *Beaver Hills and Elk Island National Park* (AB)
6 *Mont-Mégantic International Dark-Sky Preserve* (QC)
7 *Gordon's Park* (ON)
8 *Grasslands National Park* (SK)
9 *Bruce Peninsula National Park* (ON)
10 *Kouchibouguac National Park* (NB)
11 *Mount Carleton Provincial Park* (NB)
12 *Kejimkujik National Park* (NS)
13 *Fundy National Park* (NB)
14 *Jasper National Park Dark-Sky Preserve* (AB)

15 *Bluewater Outdoor Education Centre – Wiarton* (ON)
16 *Wood Buffalo National Park* (AB)
17 *North Frontenac Township* (ON)
18 *Lakeland Provincial Park and Provincial Recreation Area* (AB)
19 *Killarney Provincial Park* (ON)
20 *Terra Nova National Park* (NL)
21 *Au Diable Vert* (QC)
22 *Lake Superior Provincial Park* (ON)

Urban Star Parks

23 *Irving Nature Park* (NB)
24 *Cattle Point, Victoria* (BC)

Nocturnal Preserves

25 *Ann and Sandy Cross Conservation Area* (AB)
26 *Old Man on His Back Ranch* (SK)

Glossary and Tables

aphelion	The point on an orbit that is farthest from the Sun.
apogee	The point on its orbit at which the Moon is farthest from the Earth.
appulse	The apparently close approach of two celestial objects; two planets, or a planet and star.
astronomical unit	(AU) The mean distance of the Earth from the Sun, 149,597,870 km.
celestial equator	The great circle on the celestial sphere that is in the same plane as the Earth's equator.
celestial sphere	The apparent sphere surrounding the Earth on which all celestial bodies (stars, planets, etc.) seem to be located.
conjunction	The point in time when two celestial objects have the same celestial longitude. In the case of the Sun and a planet, superior conjunction occurs when the planet lies on the far side of the Sun (as seen from Earth). For Mercury and Venus, inferior conjunction occurs when they pass between the Sun and the Earth.
direct motion	Motion from west to east on the sky.
ecliptic	The apparent path of the Sun across the sky throughout the year. Also: the plane of the Earth's orbit in space.
elongation	The point at which an inferior planet has the greatest angular distance from the Sun, as seen from Earth.
equinox	The two points during the year when night and day have equal duration. Also: the points on the sky at which the ecliptic intersects the celestial equator. The vernal (spring) equinox is of particular importance in astronomy.
gibbous	The stage in the sequence of phases at which the illumination of a body lies between half and full. In the case of the Moon, the term is applied to phases between First Quarter and Full, and between Full and Last Quarter.
inferior planet	Either of the planets Mercury or Venus, which have orbits inside that of the Earth.
magnitude	The brightness of a star, planet or other celestial body. It is a logarithmic scale, where larger numbers indicate fainter brightness. A difference of 5 in magnitude indicates a difference of 100 in actual brightness, thus a first-magnitude star is 100 times as bright as one of sixth magnitude.
meridian	The great circle passing through the North and South Poles of a body and the observer's position; or the corresponding great circle on the celestial sphere that passes through the North and South Celestial Poles and also through the observer's zenith.
nadir	The point on the celestial sphere directly beneath the observer's feet, opposite the zenith.
occultation	The disappearance of one celestial body behind another, such as when stars or planets are hidden behind the Moon.
opposition	The point on a superior planet's orbit at which it is directly opposite the Sun in the sky.
perigee	The point on its orbit at which the Moon is closest to the Earth.
perihelion	The point on an orbit that is closest to the Sun.
retrograde motion	Motion from east to west on the sky.
superior planet	A planet that has an orbit outside that of the Earth.
vernal equinox	The point at which the Sun, in its apparent motion along the ecliptic, crosses the celestial equator from south to north. Also known as the First Point of Aries.
zenith	The point directly above the observer's head.
zodiac	A band, stretching 8° on either side of the ecliptic, within which the Moon and planets appear to move. It consists of 12 equal areas, originally named after the constellation that once lay within it.

The Constellations

There are 88 constellations covering the whole of the celestial sphere, but 16 of these in the southern hemisphere can never be seen (even in part) from a latitude of 40°N, so are omitted from this table. The names themselves are expressed in Latin, and the names of stars are frequently given by Greek letters (see next page) followed by the genitive of the constellation name. The genitives and English names of the various constellations are included.

Name	Genitive	Abbr.	English name
Andromeda	Andromeda	And	Andromeda
Antlia	Antliae	Ant	Air Pump
Aquarius	Aquarii	Aqr	Water Bearer
Aquila	Aquilae	Aql	Eagle
Ara	Arae	Ara	Altar
Aries	Arietis	Ari	Ram
Auriga	Aurigae	Aur	Charioteer
Boötes	Boötis	Boo	Herdsman
Caelum	Caeli	Cae	Burin (Chisel)
Camelopardalis	Camelopardalis	Cam	Giraffe
Cancer	Cancri	Cnc	Crab
Canes Venatici	Canum Venaticorum	CVn	Hunting Dogs
Canis Major	Canis Majoris	CMa	Big Dog
Canis Minor	Canis Minoris	CMi	Little Dog
Capricornus	Capricorni	Cap	Sea Goat
Cassiopeia	Cassiopeiae	Cas	Cassiopeia
Centaurus	Centauri	Cen	Centaur
Cepheus	Cephei	Cep	Cepheus
Cetus	Ceti	Cet	Whale
Columba	Columbae	Col	Dove
Coma Berenices	Comae Berenices	Com	Berenice's Hair
Corona Australis	Coronae Australis	CrA	Southern Crown
Corona Borealis	Coronae Borealis	CrB	Northern Crown
Corvus	Corvi	Crv	Crow
Crater	Crateris	Crt	Cup
Cygnus	Cygni	Cyg	Swan
Delphinus	Delphini	Del	Dolphin
Draco	Draconis	Dra	Dragon
Equuleus	Equulei	Equ	Little Horse
Eridanus	Eridani	Eri	River Eridanus
Fornax	Fornacis	For	Furnace
Gemini	Geminorum	Gem	Twins
Grus	Gruis	Gru	Crane
Hercules	Herculis	Her	Hercules
Horologium	Horologii	Hor	(Pendulum) Clock
Hydra	Hydrae	Hya	Water Snake

Name	Genitive	Abbr.	English name
Indus	Indi	Ind	Indian
Lacerta	Lacertae	Lac	Lizard
Leo	Leonis	Leo	Lion
Leo Minor	Leonis Minoris	LMi	Little Lion
Lepus	Leporis	Lep	Hare
Libra	Librae	Lib	Scales
Lupus	Lupi	Lup	Wolf
Lynx	Lyncis	Lyn	Lynx
Lyra	Lyrae	Lyr	Lyre
Microscopium	Microscopii	Mic	Microscope
Monoceros	Monocerotis	Mon	Unicorn
Norma	Normae	Nor	Level (Square)
Ophiuchus	Ophiuchi	Oph	Serpent Bearer
Orion	Orionis	Ori	Orion
Pegasus	Pegasi	Peg	Pegasus
Perseus	Persei	Per	Perseus
Phoenix	Phoenicis	Phe	Phoenix
Pisces	Piscium	Psc	Fishes
Piscis Austrinus	Piscis Austrini	PsA	Southern Fish
Puppis	Puppis	Pup	Stern
Pyxis	Pyxidis	Pyx	Compass
Sagitta	Sagittae	Sge	Arrow
Sagittarius	Sagittarii	Sgr	Archer
Scorpius	Scorpii	Sco	Scorpion
Sculptor	Sculptoris	Scl	Sculptor
Scutum	Scuti	Sct	Shield
Serpens	Serpentis	Ser	Serpent
Sextans	Sextantis	Sex	Sextant
Taurus	Tauri	Tau	Bull
Telescopium	Telescopii	Tel	Telescope
Triangulum	Trianguli	Tri	Triangle
Ursa Major	Ursae Majoris	UMa	Great Bear
Ursa Minor	Ursae Minoris	UMi	Lesser Bear
Vela	Velorum	Vel	Sails
Virgo	Virginis	Vir	Virgin
Vulpecula	Vulpeculae	Vul	Fox